A First Book *of* Canadian Art

R I C H A R D R H O D E S

Owl

Owl Books are published by Greey de Pencier Books Inc.
51 Front Street East, Suite 200, Toronto, Ontario M5E 1B3

The Owl colophon is a trademark of Owl Children's Trust Inc.
Greey de Pencier Books Inc. is a licensed user of trademarks of Owl Children's Trust Inc.

Text © 2001 Richard Rhodes

Distributed in the United States by Firefly Books (U.S.) Inc.
230 Fifth Avenue, Suite 1607, New York, NY 10001

The Canadian Art Foundation gratefully acknowledges the support of the Millennium
Arts Fund of the Canada Council for the Arts for this project.

Owl Books acknowledges the financial support of the Canada Council for the Arts,
the Ontario Arts Council, and the Government of Canada through the Book Publishing
Industry Development Program (BPIDP) for our publishing activities.

Dedication
For Dyan, Stephen and Matthew

Cataloguing in Publication Data
Rhodes, Richard, 1952–
A first book of Canadian art

Includes index.
ISBN 1-894379-21-7

1. Art, Canadian — Juvenile literature. I. Title.

N6540.R46 2001 j709.71 C2001-930427-7

Design: Barbara Solowan

Picture researcher: Rob Potton
Editor: Anne Shone
Copyeditor: Janice Weaver

Printed in Belgium

A B C D E F

Contents

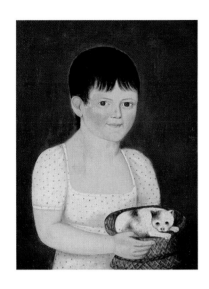

Introduction

THERE IS A START to everything. Artists begin with blank paper, or canvas, or videotape, and then go to work. It is the same with this book. It tells the story of Canadian art from the beginning, with drawings on rock, carved faces on an antler, and ritual masks. The story unfolds as Europeans arrive on the scene. They made art with what was close at hand too, first for their church, then for themselves. As the country's forests turn into farms, and towns grow, we see portraits of the people who lived here and paintings that tell their history. Thoughout, the landscape has given Canada its identity, and our artists the continuing theme of its discovery and description. But the story doesn't stop there. The world has come closer. People migrate, information flows, art belongs to a global culture. Looking at this book, remember: in its time, each work of art was a brand new part of a brand new world. —RICHARD RHODES

The palette of artist Douglas Walker, 2001

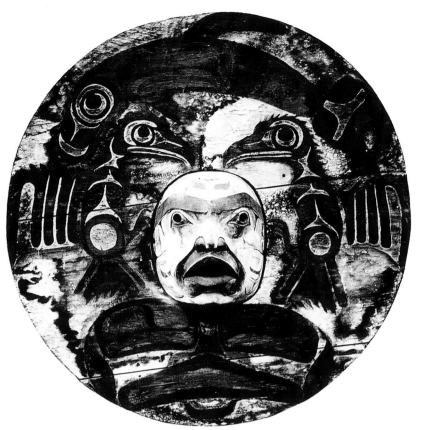

A carved and painted Bella Coola mask

◀ **WEST COAST NATIVES** used carved wooden masks in their ceremonial dances and rituals. Whether Haida, Tlingit, Kwakiutl, or this painted Bella Coola one, the masks provide us with a rich record of local animal life and tribal mythology. This exquisitely detailed circular mask, with its expressive face, is from B.C.'s central coastal region.

Thousand-year-old antler wand excavated from a Dorset village

▲ **AN ANCIENT ANTLER** bears a series of faces fashioned by an Inuit carver 1,000 years ago. The faces cover every part of the antler and seem like apparitions rising in a plume of smoke. Objects like this were believed to have had magical properties and belonged to medicine men.

First
Peoples

In the years before the arrival of Europeans, native cultures flourished in North America. Through the surviving evidence of sculptural objects and images, we see the rich and varied artistry of Canada's indigenous peoples. From the eastern woodlands to the central plains to the Pacific and Arctic coasts, these early artists, working with natural materials found in their tribal areas, created a legacy of spiritual and imaginative connection to the environment. Their art often tells powerful stories of transformation and generates images of mythical beginnings.

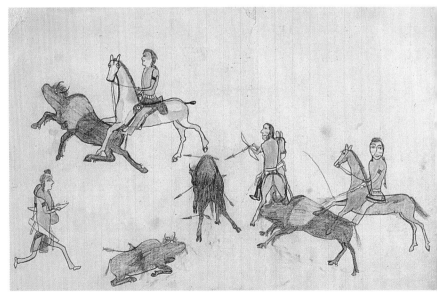

HONGEEYESA, *Ledger Art, 1897*

▲ **DRAWING ON MANUFACTURED** paper, a native artist depicted one of the final buffalo hunts on the prairies. At the time this drawing was made, in the late 19th century, native peoples were being forcibly relocated to reservations as development moved west with the railways. This type of ledger art, with its store-bought materials, is poignant as it captures a passing way of life.

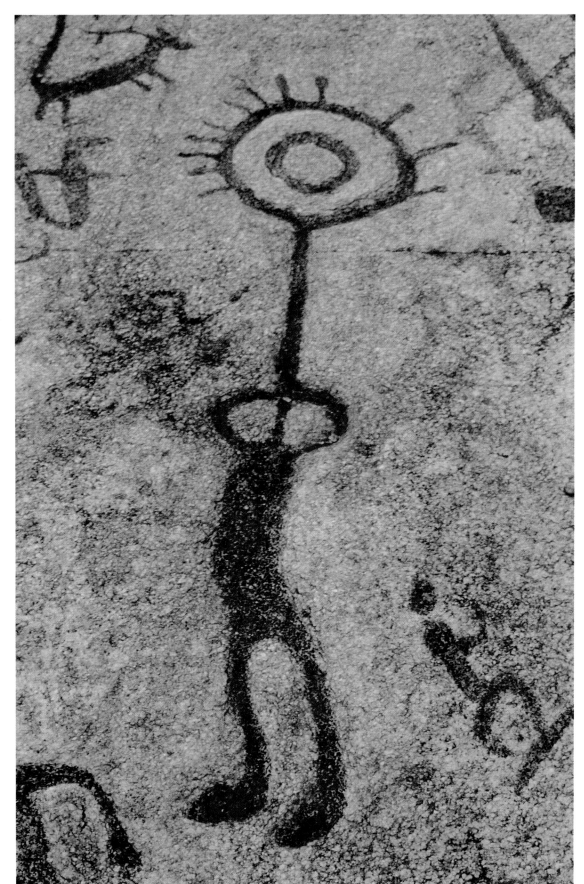

▶ ROCK CARVINGS
made 600 to 1,000 years
ago were rediscovered in
a thickly wooded forest
north of Peterborough,
Ontario, in 1954. Several
hundred figures had been
carved into an outcrop of
marble by Algonquin
natives, whose name for
the site means "the rocks
that teach." The figure
here is thought to be
Gitchi Manitou, the Great
Spirit, or Creator. Other
carvings show turtles,
cranes, snakes, rabbits,
thunderbirds, and boats.

Gitchi Manitou figure at Petroglyphs Provincial Park, Ontario

Art in New France

Art in the new colony of Quebec, or New France, was in service of the Roman Catholic Church. The earliest works were made as altar decorations or as prayer offerings, like the painting to the right. The artists were usually priests. One of the best known is Frère Luc, a Récollet brother born in France as Claude François. An artist and an architect, François spent only a short time in Quebec, from August 1670 until October of the following year. His influence, however, was great. Through his paintings, we see the faces and register the character of important historical figures in New France, like the man shown below, François Laval, the powerful first bishop.

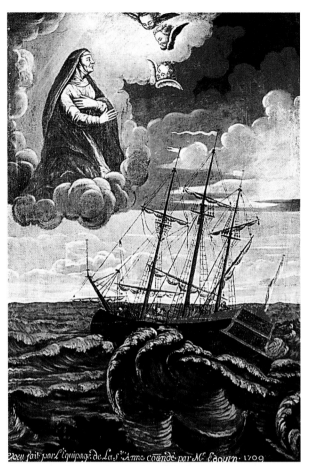

ANONYMOUS, *Ex-voto de Monsieur Édouin*, 1712

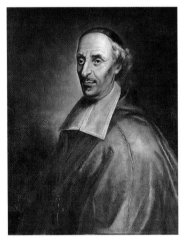

CLAUDE FRANÇOIS (*FRÈRE LUC*),
Portrait of Monseigneur Laval, 1672

▶ **HUGUES POMMIER** was a missionary priest from France. During his fifteen-year stay in Quebec, he used his talents as a painter to produce several portraits. The painting opposite is one of the best known. The subject was a revered nun who died in Quebec City in 1668. The artist made his likeness of her only hours after her death. The painting was later retouched by another artist to make her seem as she was in life. Pommier also painted one of the most famous women of the day, Marie de l'Incarnation, who came from France to establish the Ursuline Order in Canada and then, for more than thirty years, devoted herself to education, compiling the first Algonquin and Iroquois dictionaries.

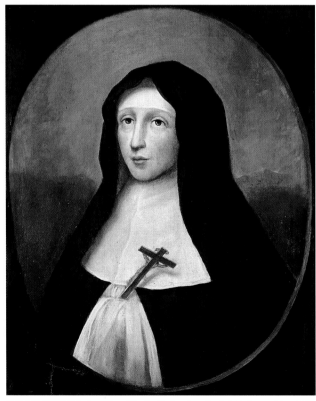

HUGUES POMMIER, *La Mère Marie-Catherine de Saint-Augustin*, 1668

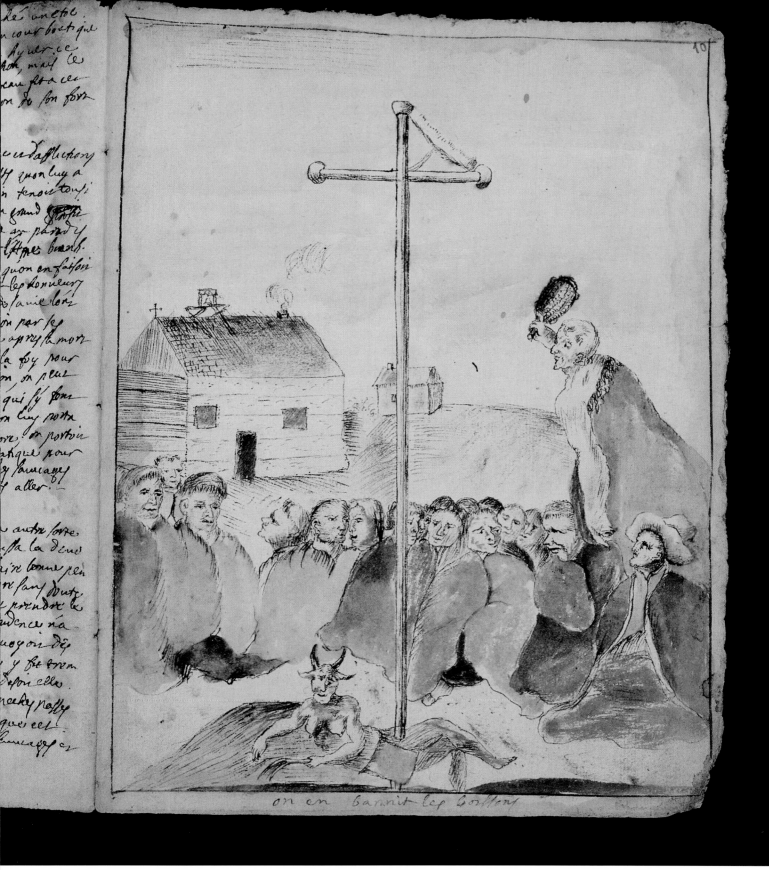

Father Claude Chauchetière, *The Repudiation of Alcohol*, 1686

▲ **CHAUCHETIÈRE WAS A JESUIT** missionary and painter who spent several years at an Iroquois mission. He used the illustrations in his journal to teach his parishioners. Here we see a sermon against alcohol, which had become a major barter good in the fur trade.

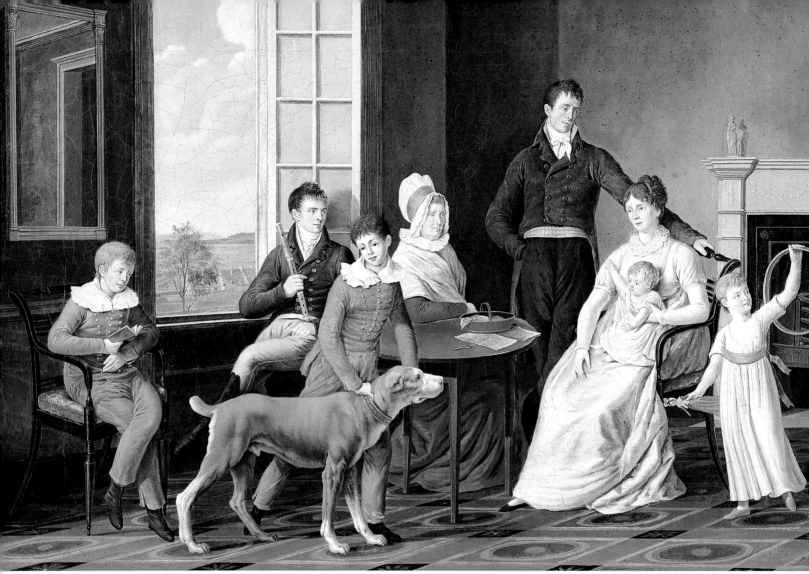

WILLIAM BERCZY, *The Woolsey Family*, 1809

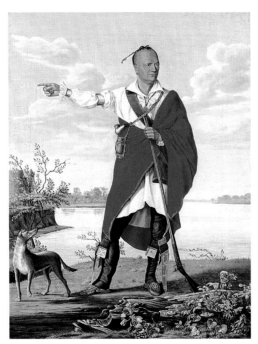

WILLIAM BERCZY, *Thayendanegea (Joseph Brant)*, 1807

William Berczy
and Portrait Painting

By 1805, William Berczy was established as a portrait painter in Montreal. For the German-born Berczy, North America was a haven for settlement, and his paintings celebrate an emerging sense of order. He met early success with a heroic painting of the Mohawk chieftain Joseph Brant, who was an important British ally. However, Berczy is best known for his portrait of the Woolsey family of Quebec City. It is a remarkable picture, and one of the most complex in early Canadian art. The painting shows three generations in the family drawing room. Through the open window, we see a sun-lit view of their lands. Reflections of a doorway in a mirror provide an added sense of interior space and a touch of mystery. With its domestic setting, the painting shows that the wilderness has been transformed into a home, into a place of belonging.

▼ **THE VOLCANO** in the background and the pineapple on the dish tell us the woman in this painting is somewhere in the Caribbean, likely one of the French islands where the artist, François de Beaucourt, had spent time before returning to Canada. He completed his painting, which art historians believe was a personal memento, in the year of his return.

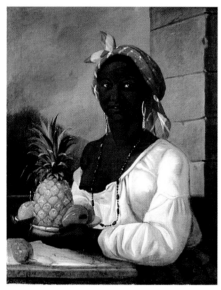

FRANÇOIS MALEPART DE BEAUCOURT
Portrait of a Negro Slave, 1786

FRANÇOIS MALEPART DE BEAUCOURT
Eustache-Ignace Trottier dit Desrivières, 1793

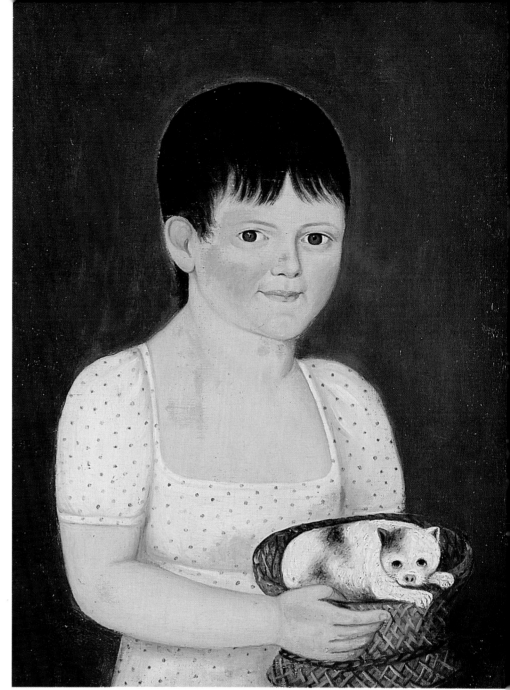

ANONYMOUS, *Girl with Cat,* undated

◄ **BEAUCOURT WAS** born in Quebec in 1740. As a young man, he left for France to be trained in art. For a number of years, he travelled across Europe as an itinerant painter, once even visiting the Russia of Catherine the Great. In his forties, he made his way back to Canada, settling in Montreal, where he established himself as a local portrait painter and decorator. His pictures have a charming, cheerful atmosphere that shows the emergence of an art that is not wholly tied to the church. In this picture, his subject is a card player.

▲ **WE DON'T KNOW** who the painter was, but the girl we feel we know. She looks out from across two hundred years as if we had met her with her cat only yesterday. The artist's picture conveys this intimate and personal atmosphere. The style is simple and plain, but the painting still conveys to us a timeless face, bright with fresh experience.

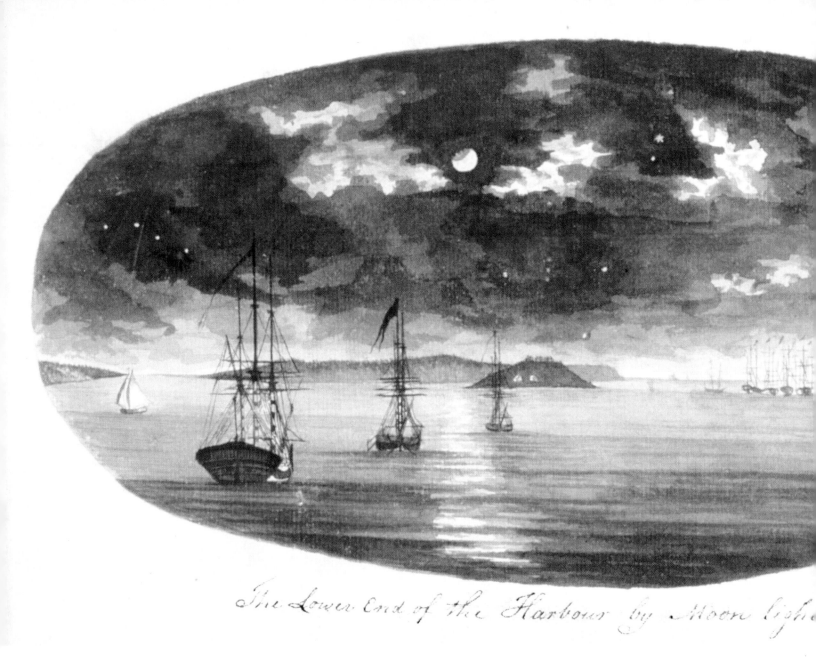

The Lower End of the Harbour by Moon Light

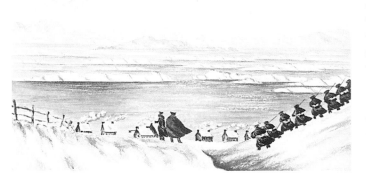

RICHARD GEORGE AUGUSTUS LEVINGE, *The 43rd Regiment marching to Canada from New Brunswick, arrival at the St. Lawrence River, December, 1837*

◀ **THE MARCHING** troops may seem as stiff as tin soldiers, but there is drama in this little watercolour of British forces in Quebec during the Rebellion of 1837. The high point of view chosen by the artist shows the smoking chimneys of the small settlement, the broad river, the ice floes, and the distant mountains. The officer in the blowing cape presides. It is a white landscape where the dark soldiers dominate. Their control is never in question; there are more soldiers shown than houses.

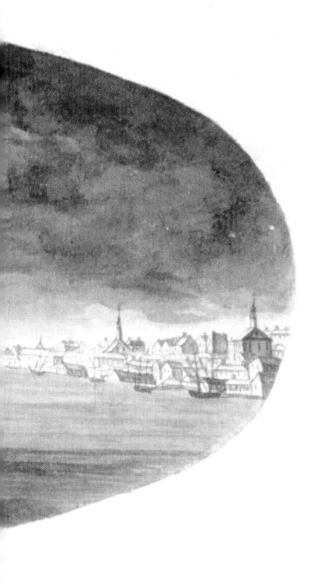

Military Topographers

Canada was, until 1867, a colony of Great Britain, and British troops were routinely stationed in cities and forts across what was then called British North America. Many of the young officers serving in these garrisons received training in drawing at military academies in England. They learned topographic drawing, which, in the days before photography, was a way to accurately record geographic details of the countryside for strategic planning. In their leisure time, however, some of these officers turned their skill to creating more personal and fanciful images. In their pictures, we often see romantic English versions of the Canadian landscape. Whether made on the job or at play, their drawings, watercolours, and paintings initiated the love of landscape in the Canadian art that followed.

JAMES S. MERES, *The lower end of the harbour by moonlight, Halifax, Nova Scotia*, 1786

CHARLES RANDALL, *Charlottetown on the island of St. Johns* (P.E.I), c. 1778

▼ **THE LONG HORIZONTAL** format is suited to showing landscape. Here the reddish lip of land runs like a stripe through the middle of the picture. Sea, sky, houses, boats, and English flags are spaced out like marks on a ruler. The painting is not so much about seeing the landscape as identifying its outlines, like the ships in silhouette. The oval shape of the image above left disguises another horizontal picture. The curves soften the image, and make it more subjective. Its emphasis is less on the description of Halifax harbour than the romantic moonlight.

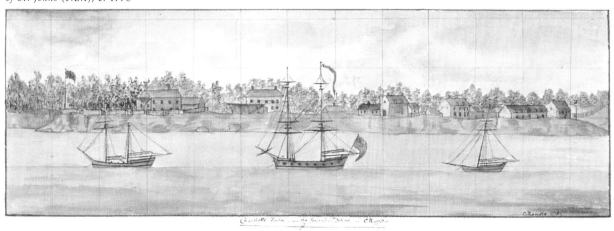

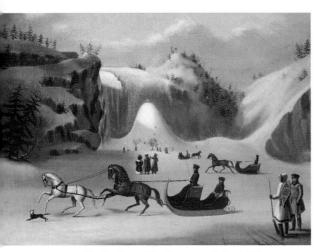

The Ice Cone, Montmorency Falls, 1845

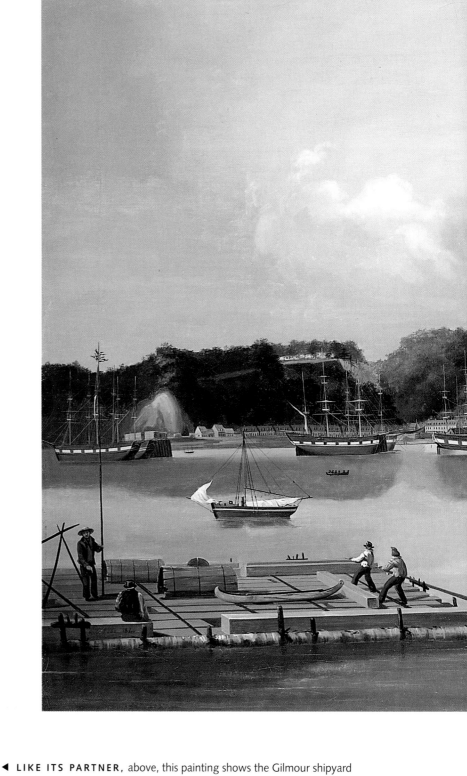

Robert **Todd**

Robert Clow Todd was born in England and came to Lower Canada (Quebec) in 1834. He was first a carriage painter, then became known for portraits, landscapes, and pictures of prize horses. The winter view of Montmorency Falls (above) is one of his most famous images. The profile figure-groups recede into the landscape. Their crisp contours have led some to call Todd's style "linear." The effect is an innocent, naive touch, like folk art. Todd faced stiff competition after Cornelius Krieghoff's arrival in Quebec City and moved on to Montreal. He continued to paint there until his death in 1866.

The Timber and Shipbuilding Yards of Allan Gilmour and Company at Wolfe's Cove, Quebec, Viewed from the West, 1840

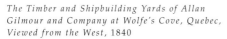

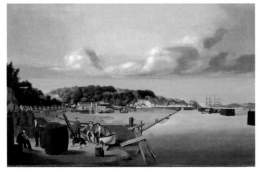

◀ **LIKE ITS PARTNER,** above, this painting shows the Gilmour shipyard in Wolfe's Cove, Quebec, in 1840. Commissioned by the Glascow-based timber firm, the paintings covered two views, one to the west and one to the south. There is a clear conceptual division between them. One shows the land side of the operation, the other the sea-going side. Todd's experience as a carriage painter shows. Part of the charm of the paintings is their smooth, finely lacquered surface, which adds to the calm, glistening appearance of the water.

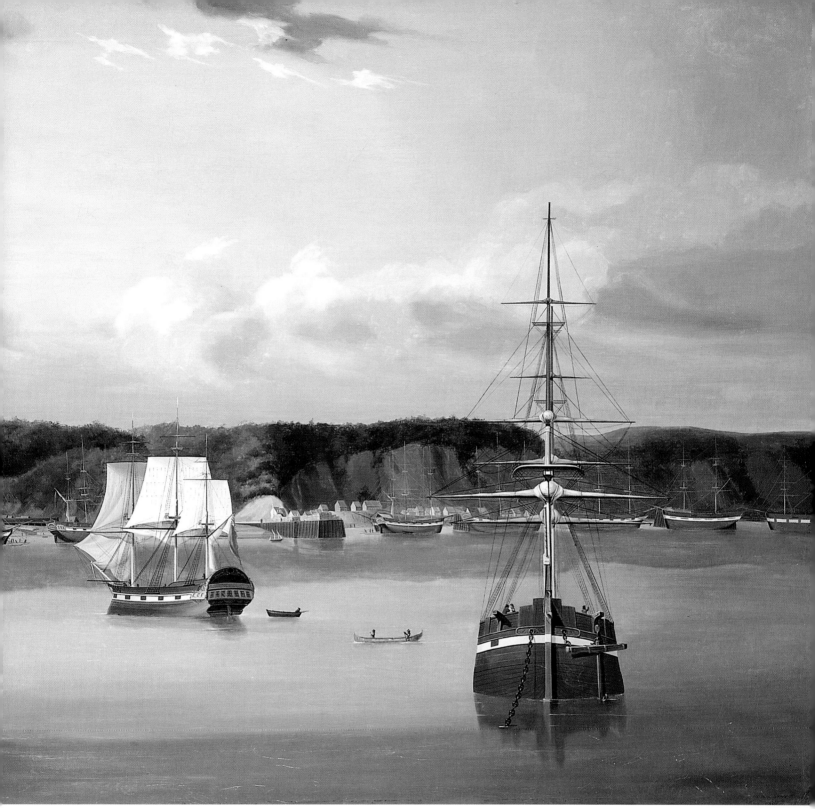

The Timber and Shipbuilding Yards of Allan Gilmour and Company at Wolfe's Cove, Quebec, Viewed from the South, 1840

▲ **TODD'S STYLE** is sometimes unsophisticated and his grasp of perspective, rendering of three-dimensional space, is only basic, but his paintings offer their own pleasures. Views like this one are based on long observation, and Todd adjusts the elements in the picture to recreate looking at the actual scene. In this picture, we see ships at anchor in the St. Lawrence River, near Quebec City. The view is a long one across the water, to the height of land and the sky above. Todd places the ships to direct our eyes and control how quickly we look at the painting. The raft on the left is moving to the right. The white-sailed ship at the centre angles back to the left. The tall-masted ship is painted straight on, with its anchor chain dropping into the still reflection. In between, smaller boats, parallel with the raft, help refocus our eyes and create a sense of distance across the glassy sheen of the water. The clouds above hover with the same slow, fluid pace.

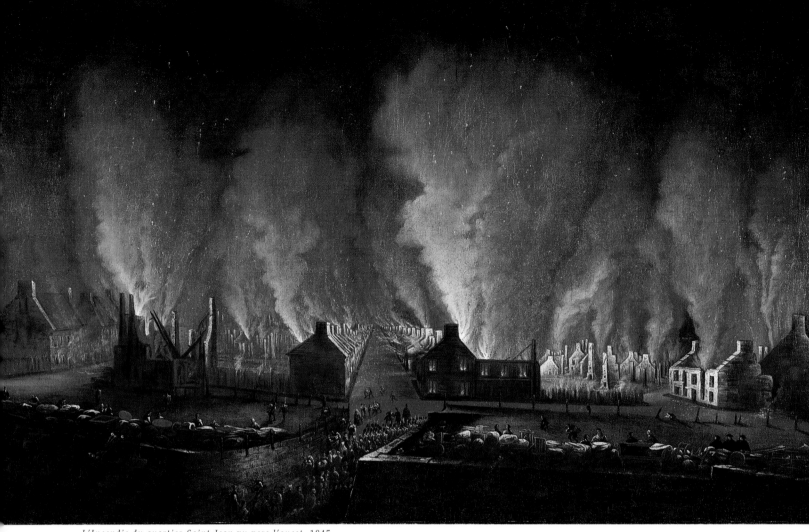

L'Incendie du quartier Saint-Jean vu vers l'ouest, 1845

Joseph Légaré

Not many painters become community leaders, but Quebec's Joseph Légaré was an exceptional man. In the 1820s, the self-taught artist became the first Canadian-born landscape painter. He also opened the country's first art gallery. In addition to being a prolific painter, Légaré worked as a justice of the peace, agitated for political reform, faced arrest in the Rebellion of 1837, and started a club devoted to working-class education. He also helped organize the Quebec City Board of Health. His ultimate legacy is perhaps the proud French nationalist spirit of Quebec's St-Jean-Baptiste Society. He was one of the society's founding members in 1834.

▲ **LÉGARÉ CAME** to be best known for his dramatic paintings of disasters: Indian wars, cholera epidemics, raging fires. The ones shown are from a series on a spectacular fire in Quebec City the night of June 28, 1845. Two city districts burned, and more than 1,300 houses were destroyed.

▼ **THE PAINTINGS** in the series have ended up in different museum collections, but each had a mate showing a view in the opposite direction. Légaré's idea was to display them to a paying public in a panoramic exhibition and use the proceeds to aid the 10,000 people left homeless.

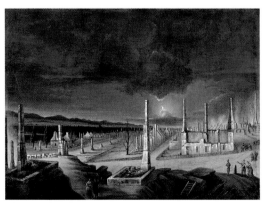

Les ruins après l'incendie du quartier Saint-Jean vues vers l'est, 1845

Antoine
Plamondon

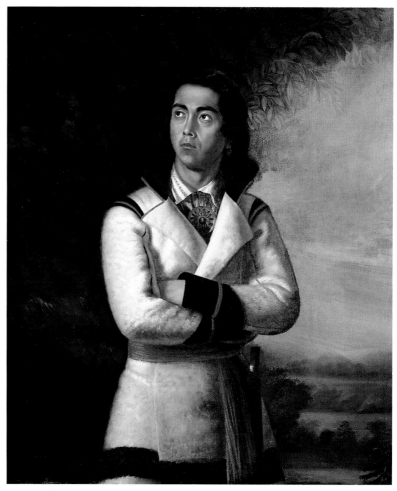

Born a grocer's son in 1804, Antoine Plamondon was apprenticed as a youth to Joseph Légaré. By 1825, he had a studio in Quebec City, but soon won a scholarship to study in Paris, where he was taught in the classical style of the day. Returning to Quebec in 1830, he began work on church commissions and gave lessons in drawing. With his Paris credentials, Plamondon became a local authority on art. His rivals sometimes felt the sting of his opinions in reviews he wrote for the newspapers. Commenting on the difference between good and bad painting, he once complained that bad paintings existed "because there are buyers of bad paintings." Dismayed by the changing cultural scene in Quebec City, he retreated to the country, where he painted until his death in 1895.

Portrait of Zacharie Vincent, 1838

Portrait of a Man, 1841

◀ **PORTRAIT** paintings were the basis of Plamondon's career. Fees from his sitters paid his way as an artist. He charged $40 for a large portrait, $18 for a small one. However, the new, emerging art of photography soon offered his professional clientele another option.

▶ **FOR PLAMONDON,** the classical style meant crisp, clean drawing and full light that brought definition and dignity to his subjects. In many portraits, the sitters look out with a straight, level gaze that is almost confrontational. Despite the stiff poses and simply painted backgrounds, there is no mistaking the power of their individual personalities.

▲ **SHOWN AS A STYLISH** young man, Zacharie Vincent was a Huron native who lived in Plamondon's home town of Ancienne-Lorette, just west of Quebec City along the St. Lawrence River. Like Plamondon, he was a painter. He was also the subject of a now lost painting, *The Last Indian*, which was bought by Lord Durham, a governor general of British North America.

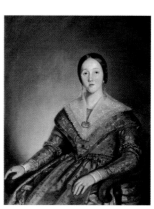

Madame Joseph Guillet dit Tourangeau, née Caroline Paradis, 1842

Paul Kane

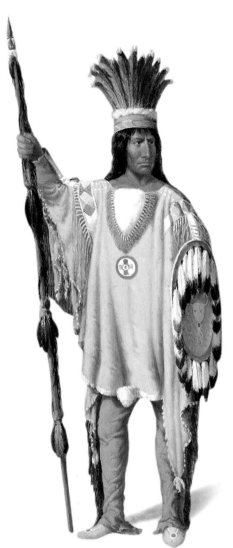

Adventure in the West of the 1840s was on Paul Kane's mind when he came back to Canada after touring European portrait galleries. In England, he had met the American artist George Caitlin, who had lived among the Plains Indians. Kane was inspired. He set out on travels lasting two and a half years, "to sketch pictures of the principal chiefs, and their original costumes, to illustrate their manners and customs, and to represent the scenery of an almost unknown country."

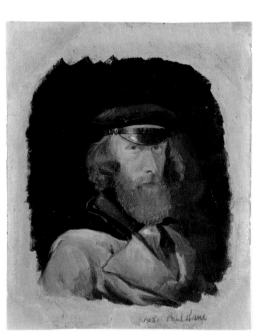

Self-Portrait, 1846–48

▲ **KANE'S ABILITY** to draw gave him a reputation among the chiefs he painted. Yet not all were ready sitters. Some said they were reluctant because their portraits might end up in the hands, and thus the power, of their enemies.

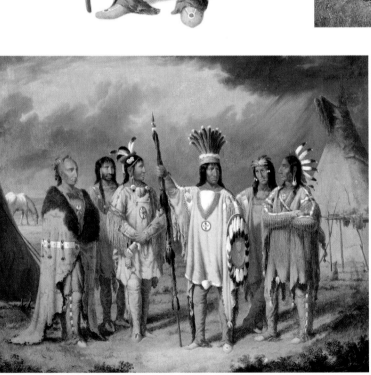

Big Snake, Chief of the Blackfoot Indians, Recounting his War Exploits to Five Subordinate Chiefs, 1851–56

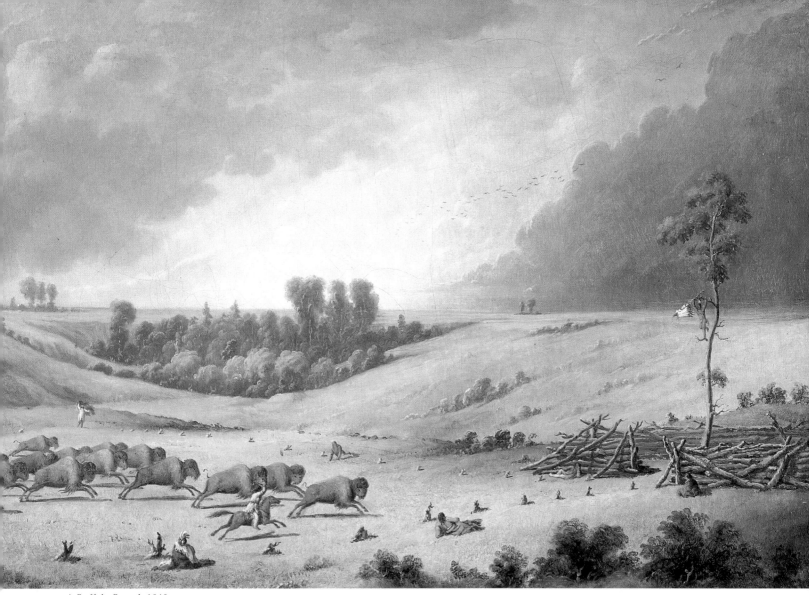

A Buffalo Pound, 1848

François Lucée, Métis Guide, 1847

▲ **RELYING ON** the sketchbooks and artifacts that he had kept safe in a battered tin box on his journey, Kane quickly began work on a cycle of 100 paintings once he returned to Toronto. From watercolours and pencil notes, he recreated scenes he had witnessed, like a buffalo hunt near the North Saskatchewan River. The painting shows a herd panicked by the smell of grass smoke flares as they run into a wooden pen built on the open prairie.

◄ **CREE, BLACKFOOT,** Saanich, and Ojibwa tribes were among the many Kane met on his trek from the Great Lakes to the Pacific. Travelling between Hudson's Bay Company outposts, he recorded the landscape and the people he met, in often intricate detail. As an artist, Kane possessed a reporter's eye and produced a vibrant image of a vanished past.

Otisskum, or "The Horn," 1846

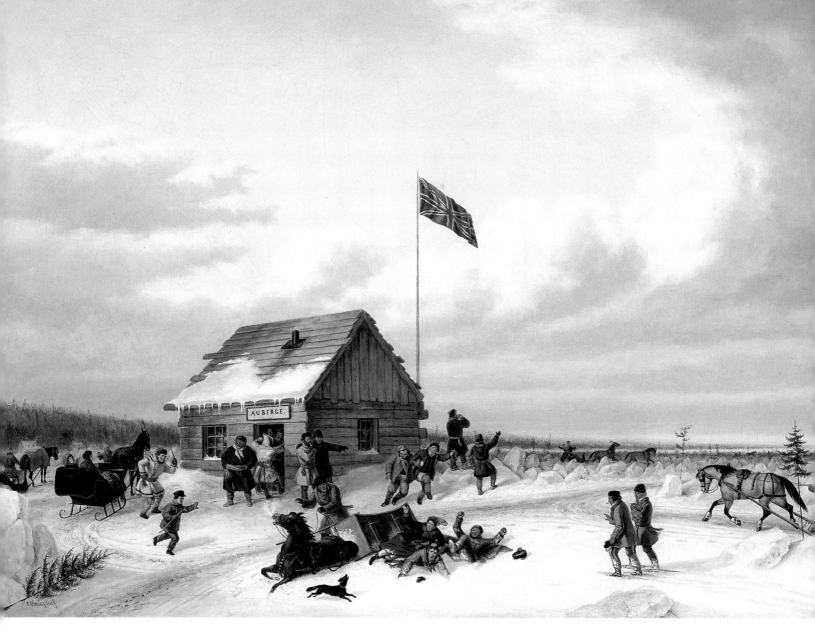

Cornelius
Krieghoff

Storytelling shaped Krieghoff's art from the beginning. In his paintings, small details abound, inviting viewers to spend time looking as a story unfolds. Europe called this kind of art genre painting, and Krieghoff would have seen many such images in Germany as a child and a young man. When Krieghoff began working as an artist after settling in the Montreal area, these paintings became the major influence on his work. In his lifetime, he gained a wide reputation for the elaborate richness of his "Canadian" images. They show great sympathy for the people, the land, and the habits that create the unique culture of a place.

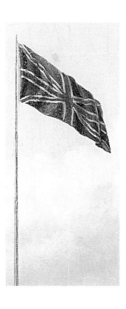

▲ **THE END** of an era is shown in this late painting by Krieghoff. It dates from 1871, his last year in Canada and the year British troops were withdrawn from Quebec City. They had been stationed there since the Conquest of 1759. Krieghoff sets his painting at the start of this last year of occupation. The British Union Jack flies crisply over the scene, framed by blue sky. He makes it part of the celebration mood.

▶ **KRIEGHOFF'S** closest friends were British military officers. His own experience in the U.S. army would have made him feel comfortable in their company, sharing common interests in hunting, literature, and entertainment.

▼ **THE SKY** is an important part of Krieghoff's paintings. Stormy, clear, or both—like here—it sets the mood for the scene. There is great accuracy in this rendering of colour and cloud formation, and the reflective light they cast on the land. Here the Citadel of Cape Diamond is shown softly shadowed in the distance under low, grey winter cloud.

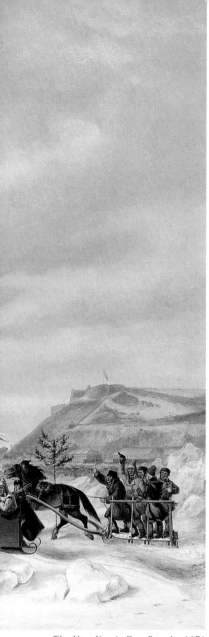

The New Year's Day Parade, 1871

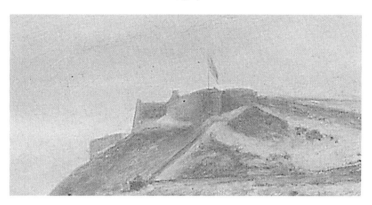

▼ **THE PEOPLE** of Krieghoff's world in Quebec converge on the little inn erected on the January ice of the St. Lawrence: military men, townspeople, and rural *habitants*. Merrymaking is one of Krieghoff's great themes. He generally made happy pictures where pleasure and camaraderie hold a vast landscape at bay. Here looping arcs of sleigh tracks suggest a cycle of arrivals and departures, and give the painting a sense of time. The icicles along the roof point to the warmth inside the cabin, as does the round, friendly man wrapped in his blanket coat.

Messrs. Remington and Ralph hunting, Montreal, 1889

William Notman

He has been called Canada's first internationally known photographer, but William Notman, born in Scotland in 1826, was better known in his lifetime by the words on the marquee of his Montreal studio: "Photographer to the Queen." The queen was Queen Victoria, and Notman's royal recognition came after she saw his photographs recording the building of the Montreal bridge that is named in her honour.

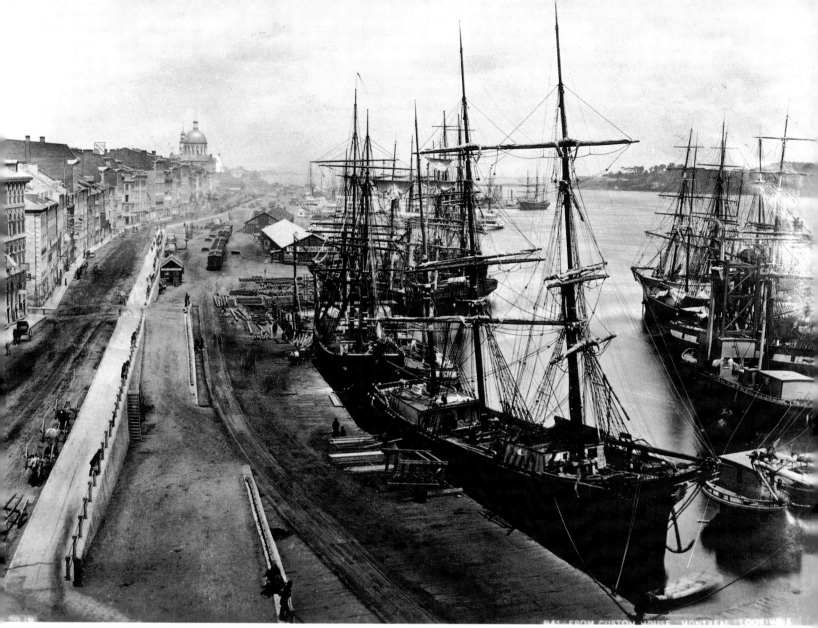

Montreal from Custom House looking east, 1878

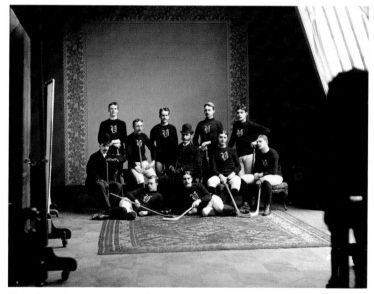

Victoria hockey team, Montreal, 1888

▲ **SORTED UNDER** the general title "Views Across Canada" Notman left hundreds of images, now mostly kept by the McCord Museum in Montreal, that show Canada in its early years of nationhood. Unlike the paintings of the day, which concentrated on nature scenes, Notman's photographs provided a record of Canadian cities being transformed by the booming commercial development of the times.

◄ **PHOTOGRAPHIC PORTRAITS** had largely replaced painted ones by the 1860s, when Notman launched his photographic studio. Success soon brought branches in Toronto, Ottawa, St. John, Halifax, Albany, and Boston. In a sky-lit space that he called the operating room, he took many group portraits. He also staged special "Canadian" portraits. On the opposite page, in the light coat, we see the famous "Wild West" painter Frederick Remington.

Lucius O'Brien

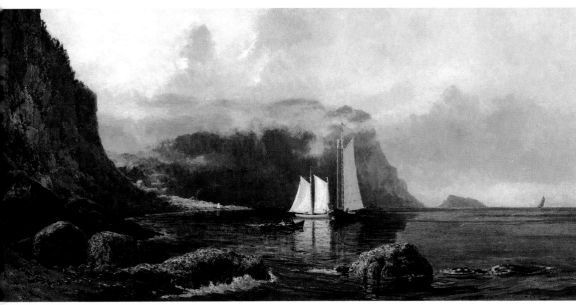

Northern Head of Grand Manan, 1879

◄ **CANADA HAD** new national horizons after Confederation in 1867. Lucius O'Brien was an artist who crossed the country from the Maritimes to Quebec and Ontario, recording its water vistas. When the new Canadian Pacific Railway was completed in 1885, he travelled on to the Rocky Mountains and the West Coast to make paintings. The geographic range of his work created the first comprehensive image of a Canada that truly stretched from coast to coast.

Mr. O'Brien is a very tall slight man with aquiline features big black and grey whiskers and probably about forty-five years old. He is very quiet and deliberate in his manner, an exceedingly good talker and a refined man generally. He is a landscape painter exclusively choosing generally marine views, he is a very enthusiatic boatman." This description comes from the pen of another artist in Ottawa on the eve of the founding of the Royal Canadian Academy in 1880. This professional organization, which O'Brien headed for ten years, began as an effort to create national unity with annual art exhibitions in the country's major cities. From it, the National Gallery of Canada evolved.

▶ **AS A YOUNG MAN** O'Brien tried to make his way as an artist in Toronto, without success. Until he was forty years old, he worked as a civil engineer, returning to a career as a professional artist in 1872. O'Brien specialized in romantic scenic landscapes, inspired by American artists such as Frederick Edwin Church and Albert Bierstadt. The picture on the right, of Quebec's Saguenay River, means to capture, with its lofty heights and misty distances, the vastness and newness of North America. It is one of O'Brien's first important oil paintings—he had been known mostly for his exacting watercolours. O'Brien presented it as his Royal Canadian Academy diploma picture, to best represent the academic skills he possessed as an artist.

Sunrise on the Saguenay, 1880

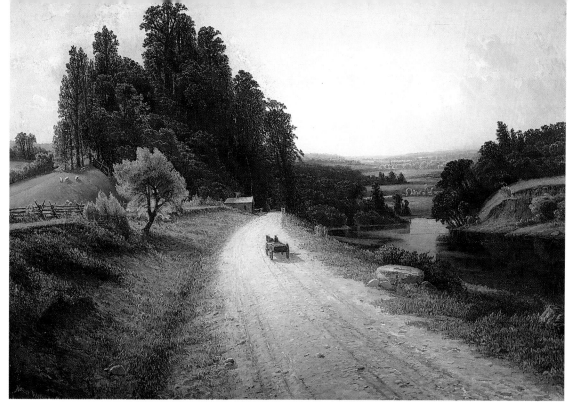

The Stone Road, 1881

Homer **Watson**

Success came early to the Ontario
painter Homer Watson. After working
alongside Lucius O'Brien at a Notman
Photographic Studio in Toronto in
the 1870s, he began to exhibit his work. In
1880, as a twenty-five-year-old artist, he sold
a painting in the first Royal Canadian Academy
exhibition. It was bought by the governor
general as a gift for Queen Victoria. The
queen herself was an accomplished landscape
watercolourist, and she soon bought two more.
Watson's reputation was made. A few years
later, the famous British author Oscar Wilde
was on a tour of North America and saw
Watson's art. When Wilde later introduced the
artist to influential friends in London, England,
he declared, "This is my find in America.
Mr. Watson is the Canadian Constable." The
comparison to John Constable, the great British
landscape painter, stuck to Watson throughout
his long career. However, Watson's interests
never strayed far from Southern Ontario.
The country was at a turning point. Nationhood
called for the creation of a sense of place.

▼ **TREES OCCUPIED**
a special place in Watson's
heart. They figure in nearly
all his landscapes. In his later
years, he set down some
thoughts about them: "Trees
are the first of all the beauties
with which the Lord has
embroidered the old earth,
and I look for types away
from the tree butchers. They
have a hard time. I must save
some to show what a beast
man is sometimes."

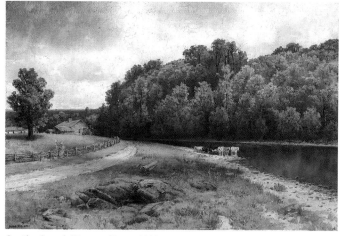

On the Grand River at Doon, 1880

James W. Morrice

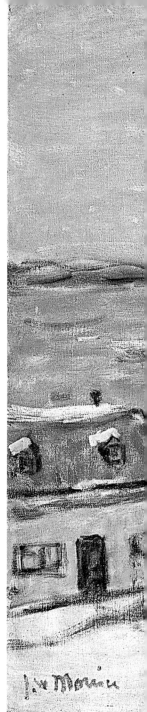

B orn in 1865 to a wealthy merchant family in Montreal, James Morrice was expected to take up a profession. As a young man, he moved to Toronto to study law. By the age of twenty-five, however, after passing his final law exams, Morrice had other career thoughts. He was interested in the arts, and he planned to go to Europe to study. He told the famous English art critic Clive Bell that he originally left Canada to be a musician—he was an accomplished flute player—but the world knows Morrice as a painter. He painted most of his pictures on small wooden panels. Easily portable, the panels gave him the freedom to note down fleeting impressions of light and colour. Many of his pictures seem to capture the temperature of a place. From 1890, he was based in Paris, France, but he left often to travel in search of new subjects. Frail health plagued Morrice for most of his life, and his restless excursions in search of subject matter sometimes seemed a private quest for sun and warmth. He died in North Africa, in Tunis, in 1924.

▶ **THE DAY IS GREY,** the water is choppy, and the damp weighs on the plume of smoke rising from the Lévis ferry boat making its way to Quebec City across the river. The scene shows Morrice's mastery of rendering subtle mood and colour in his paintings. The French painter Henri Matisse, a friend, once said that Morrice was an "artist with a delicate eye."

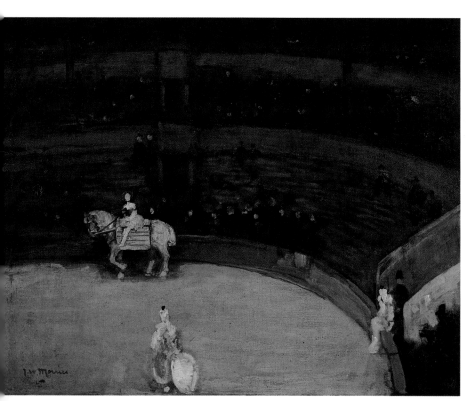

The Circus, Montmartre, 1905

◀ **IN PARIS, MORRICE** had a studio close to the banks of the Seine River. Known as a sophisticated, fun-loving character in the city's artistic circles, his routine was to set out each day looking for scenes to paint. In the evenings he would enjoy the entertainments of the city, like this circus in Montmartre. At the same time, also in Montmartre, Picasso and other young European artists were busy inventing modern art. Their influence can be seen in the simplified design of Morrice's painting. At forty years of age, however, his style was set. Over the years he would refine it again and again, but modern abstraction stayed outside his interests. Morrice was a painter of pleasure and of place.

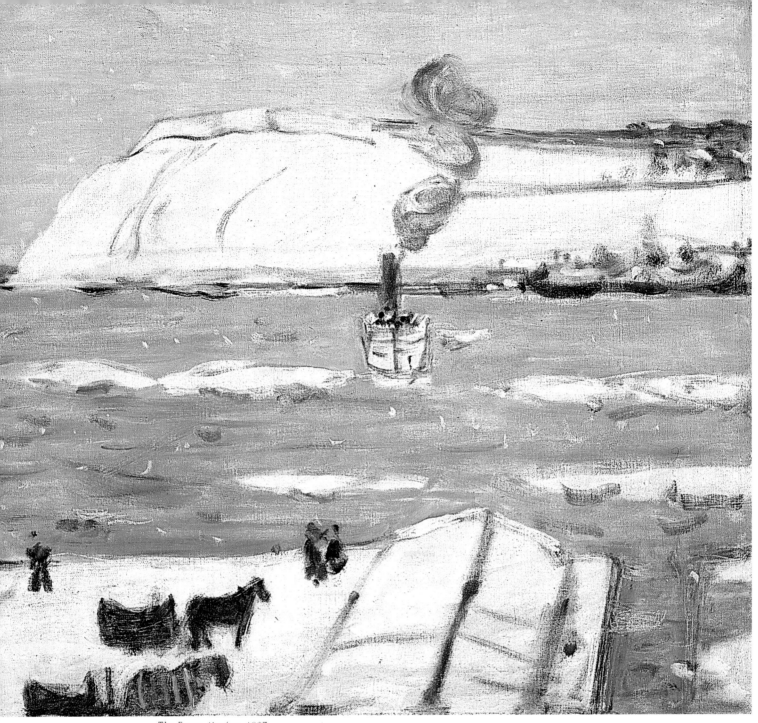

The Ferry, Quebec, 1907

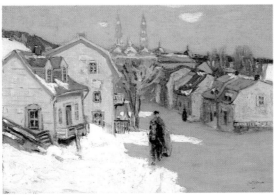

Sainte-Anne-de-Beaupré, 1897

◄ **ALTHOUGH HE LEFT** Canada to live permanently in Paris, Morrice returned to visit his family and his Canadian artist friends every year until World War I broke out in 1914. His trips were usually saved for winter, his favourite Canadian season, although this meant low temperatures, cold hands, and "stiff" paint. Morrice's Quebec winter scenes, like this one of Ste-Anne-de-Beaupré and its famous church, were popular and uniquely Canadian when he showed them at the annual Salon exhibitions in Paris.

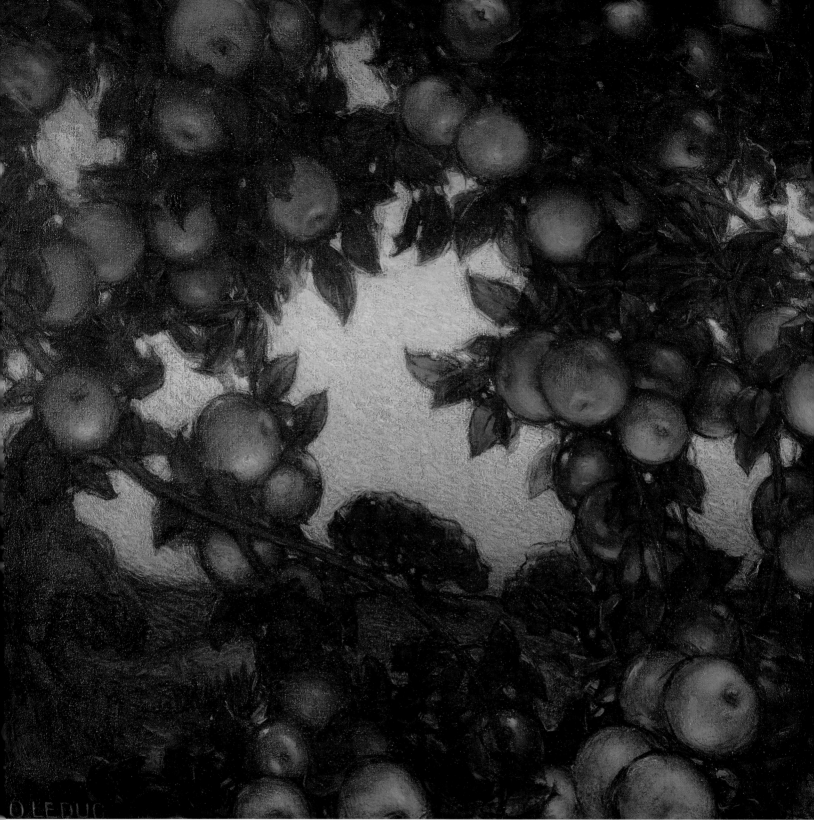

Green Apples, 1914–15

▲ **AN ANONYMOUS CRITIC** once called this Ozias Leduc painting "a poem of beauty, harmony, grace and colour." A.Y. Jackson, the Group of Seven painter, thought it was the best thing he saw at the Art Association of Montreal's annual spring exhibition of 1915. The National Gallery of Canada snapped it up for its collection. The consensus is that *Green Apples* is Leduc's masterpiece. The close-up view of the apples is arresting against the glowing gold twilight. Note how the gold light is also softly reflected onto the near side of the apples. The bower that Leduc paints comes to feel like a shelter, one where the viewer becomes the source of a second, more intimate kind of illumination.

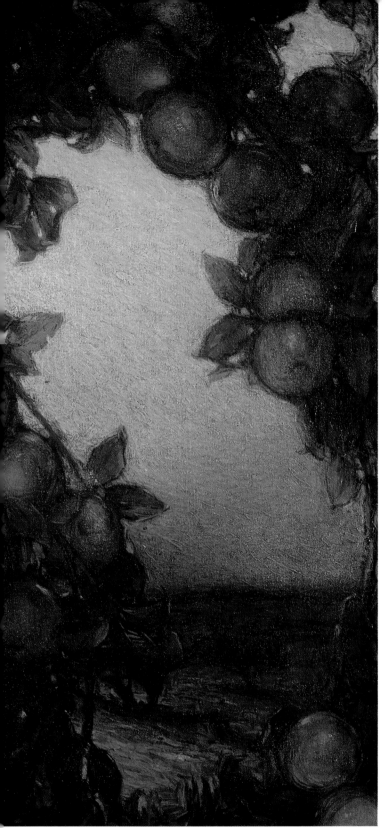

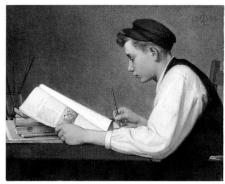

The Young Student, 1894

▲ **THE ARTIST'S** brother, Honorius, posed for this picture showing a young boy in the midst of making notes or copying an illustration from a journal. His absolute absorption holds the painting in a mood of concentrated stillness.

Ozias Leduc

S aint-Hilaire, Quebec, east of Montreal, is a small town on the side of a small mountain. It's here where Ozias Leduc lived out his long life, from 1864 to 1955. In the course of his career, he worked as a decorator of churches, painting, at first, simply for his own pleasure. His remarkable paintings, however, are now some of the most admired in Canadian art. Their exacting care and visionary intensity gave them a spiritual dimension, a quality that later was to influence a younger generation of Quebec abstract artists.

Still-life, Study by Candlelight, 1893

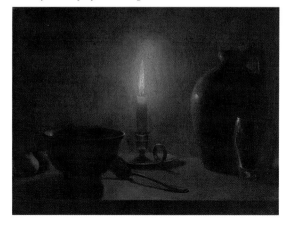

▶ **THE PAINTING** has also been called *The Farmer's Supper*, but when Leduc first showed it in 1893 his title was *Still-life, Study by Candlelight,* which is how we know the painting today. In it, Leduc renders the illumination from a single candle. The yellow-orange light is caught reflected on the curved surfaces of the jars, the rim of the bowl, and across the table top, casting a meagre shadow under the spoon. The flame seems to pulse above the translucent candle top.

MARC-AURÈLE SUZOR-COTÉ, *Youth and Sunlight*, 1913

Canadian
Impressionism

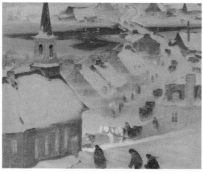

CLARENCE GAGNON, *Christmas Mass*, 1928–33

A trip to Paris to finish studies was common in the Canadian art scene at the end of the 19th century. By the 1890s, French Impressionist works by Monet, Renoir, and Degas had begun to appear regularly in Paris galleries and they greatly influenced some Canadian artists who saw them. One was Marc-Aurèle Suzor-Coté, who won a prized bronze medal at the Exposition Universelle of 1900. On returning to Quebec, he brought the Impressionists' sun-filled colours with him. He also made sculptures influenced by the style of Rodin.

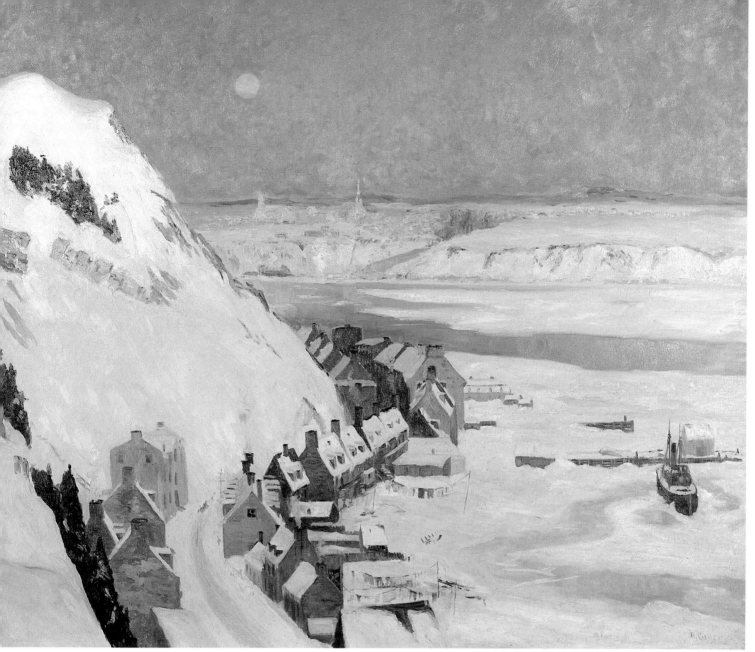

MAURICE CULLEN, *Cape Diamond*, 1910

▲ **MAURICE CULLEN** was a friend of the painter J.W. Morrice, and he found his bright Impressionist palette of colour very early. Returning from Paris to Canada in 1902, Cullen had a long and influential career. Winter was a favourite subject. He loved its blue shadows, as in this late-afternoon moonrise near Quebec City. Morrice said of him, "He is the one painter in Canada who gets at the guts of things."

▶ **CLARENCE GAGNON** was younger than Cullen and Suzor-Coté. He is known for his paintings of rural Quebec scenes near Baie-St-Paul, on the St. Lawrence north shore. In the 1930s, he created a series of illustrations for *Maria Chapdelaine,* the classic Quebec novel of family farm life.

CLARENCE GAGNON, *A Clearing, Winter,* 1925

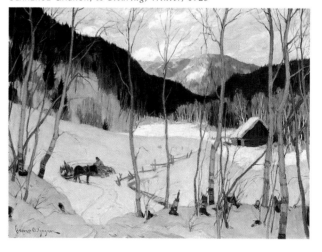

Tom
Thomson

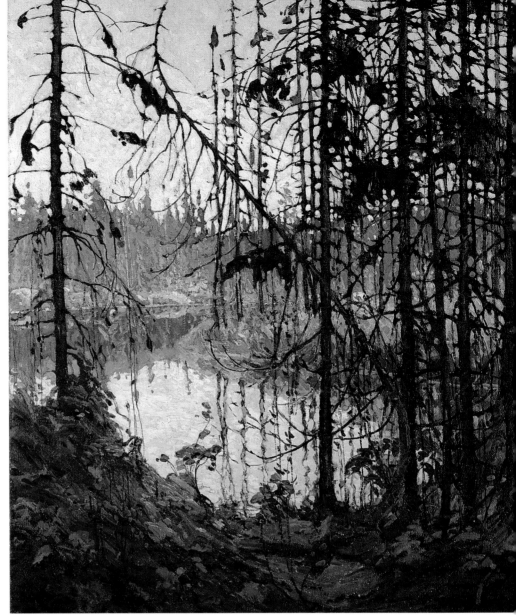

Northern River, 1915

Canada's most famous artist studied art at a small business college. He was thirty-one when he found work doing illustrations at Grip Limited, a Toronto graphics firm where he began to finally meet some serious young artists. On weekends and holidays, they would travel north to paint. In time, Thomson moved on to wilder country in the Canadian Shield. There, he developed the spectacular, colour-sensitive style that has made him a favourite. His art shows a deep, emotional response to the land and its rhythms. He died early, in 1917, drowning mysteriously, a month before he turned forty-one.

A Northern Lake, 1912–13

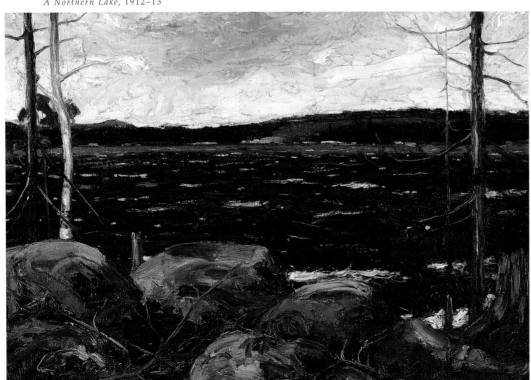

◄ **ENCOURAGED** by his painter friends after a summer trip to Ontario's Algonquin Park, Thomson took one of his sketches and scaled it up into this larger painting. It promptly sold, giving him confidence to pursue his painting career over his regular work as an illustrator. By 1914, he was spending as much time as he could in the park. Thirty years earlier it had been designated a wilderness preserve, and Thomson was captivated by its rough, undeveloped terrain. One summer he even worked as a fire ranger, but he found that there wasn't enough time left for painting.

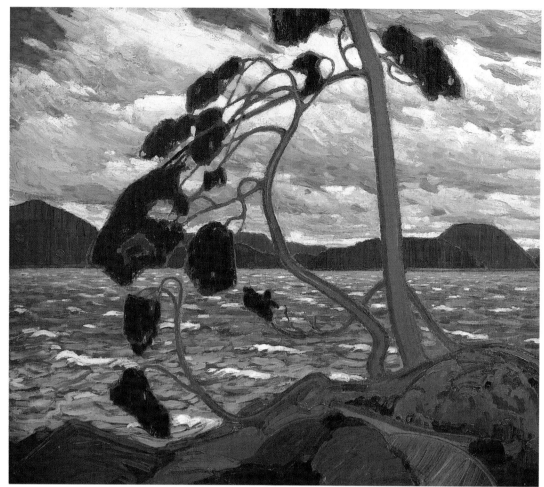

▶ **ONE OF** the largest and last of Tomson's paintings, *The West Wind* is also one of his best-known works. Tomson's friend and fellow painter A.Y. Jackson called it "one of the most important of Tom's canvases." After his death, it travelled to London and Paris, where critics thought they saw a Japanese influence in the flat shapes of the wind-blown pine. In the 1950s, a professor of forestry identified the site of the painting as being Grand Lake in Algonquin Park.

The West Wind, 1917

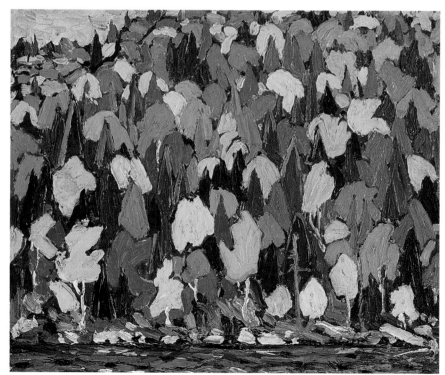

◀ **PAINTING FROM** his canoe or his campsite, Thomson usually worked small, on wooden panels he called "my boards." A few have been discovered to be pieces from fruit crates that he used when money was low. On his travels, he painted fast, showing great skill in letting every brushstroke count as a vibrant record of the colours he saw. In the last year of his life, he was making a painting a day. His idea was to show them together in a grand statement on the changing light and seasons of the North.

Autumn Foliage, undated

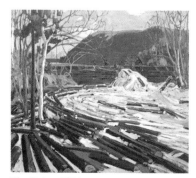

The Drive, 1916

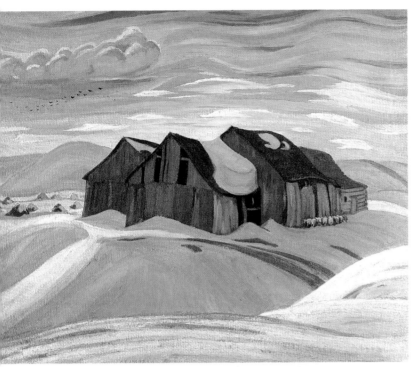

A.Y. JACKSON, *Barns*, 1926

◀ **THE RHYTHMS** of the land occupied A.Y. Jackson throughout his long career. He started out in Montreal but had settled in Toronto by 1913. On his many trips—he was proud that for most of his career, he made three a year—he criss-crossed the country, painting in Algonquin, Algoma, Quebec's Laurentians and Gaspé, Newfoundland, the Prairies, the mountains of B.C., and the Arctic. In each place he sought the lines, shapes, and colours that knitted the landscape into a whole and gave it an animated life. Jackson's paintings forged the look echoed in the paintings of the other Group members.

The Group of Seven

As young artists, the Group of Seven struggled. Art collectors took more interest in international art, and "Canadian subjects" met no ready acceptance with audiences. With their energetic landscapes, however, they tried to define a national art. The Group's identity emerged as a result of the artists' sketching trips into Algonquin Park. The trips were interrupted by World War I, but they began again in 1919, when Lawren Harris organized an excursion in a railway boxcar to Algoma, north of Lake Superior. The Group's first exhibition took place in May 1920. By 1922, they had shown in another forty. They officially disbanded in 1933. Harris, Jackson, Lismer, Varley, Carmichael, and Casson continued individual careers. MacDonald died in 1932.

▼ **ARRIVING IN** Canada from Sheffield, England, in 1912, Frederick Varley was soon invited by Tom Thomson on early Algonquin sketching trips. When he returned from World War I, he established himself as a portrait painter in Toronto, and then moved to Vancouver, where he was inspired by the mountain scenery. This picture, which includes a self-portrait, demonstrates both interests.

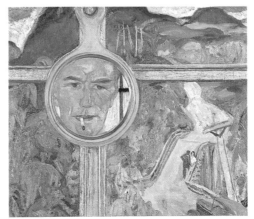

F.H. VARLEY, *Mirror of Thought*, 1937

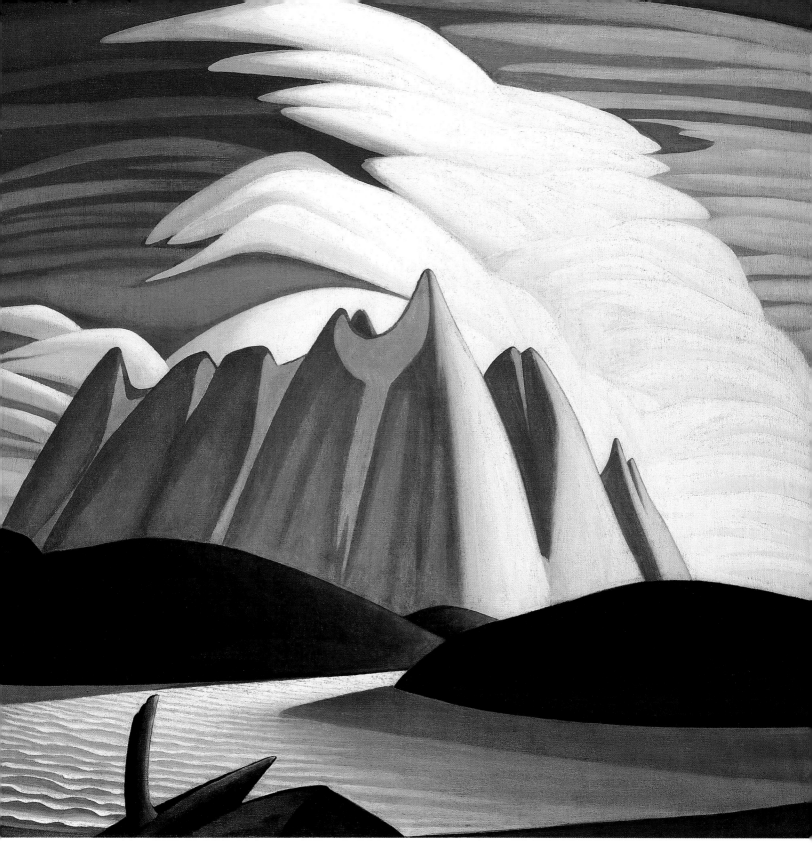

LAWREN HARRIS, *Lake and Mountains*, 1928

▲ **STARK AND COOL**, this 1920s painting by the Group of Seven leader, Lawren Harris, turns the Canadian landscape into monumental architecture. Harris was born into a wealthy family in Brantford, Ontario, and studied art in Berlin. Sketches by J.E.H MacDonald, shown at the Arts and Letters Club in Toronto, impressed him deeply, and he soon joined A.Y. Jackson and Tom Thomson on painting trips into the wilderness. A reader of philosophy, he made an art concerned with essentials, eventually even geography was replaced by pure geometric abstraction.

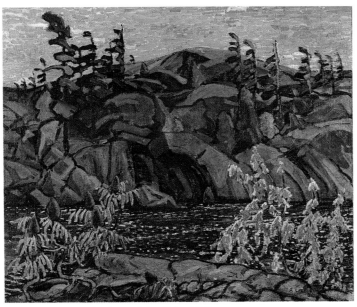

ARTHUR LISMER, *Rock Pine and Sunlight*, 1920

◀ **ALSO FROM** Sheffield, Arthur Lismer went on to make a distinguished teaching career in Toronto and Montreal. In describing one of his early sketching trips, he once wrote, "The first night spent in the north and the thrilling days after were turning points in my life."

▼ **THE ELEVATED** perspective of this silver mine was a typical point of view in the art of Orillia's Franklin Carmichael, who showed a love for vistas and deep horizons in his paintings. Working as an industrial designer and illustrator, Carmichael revelled in contrasting architectural shapes with the long-line contours of the landscape.

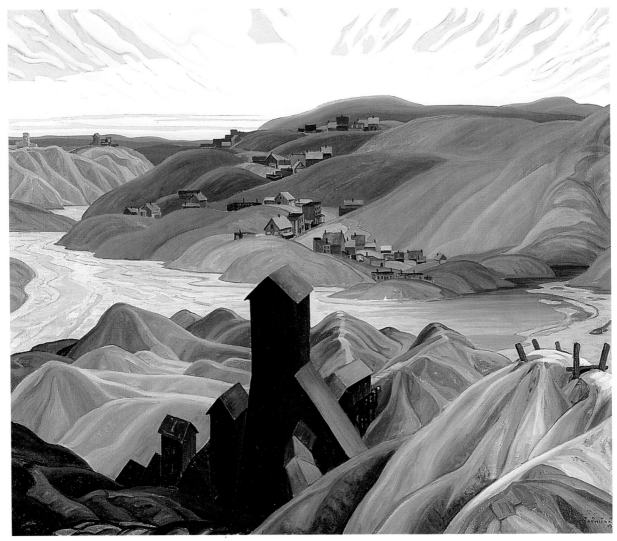

FRANKLIN CARMICHAEL, *A Northern Silver Mine*, 1930

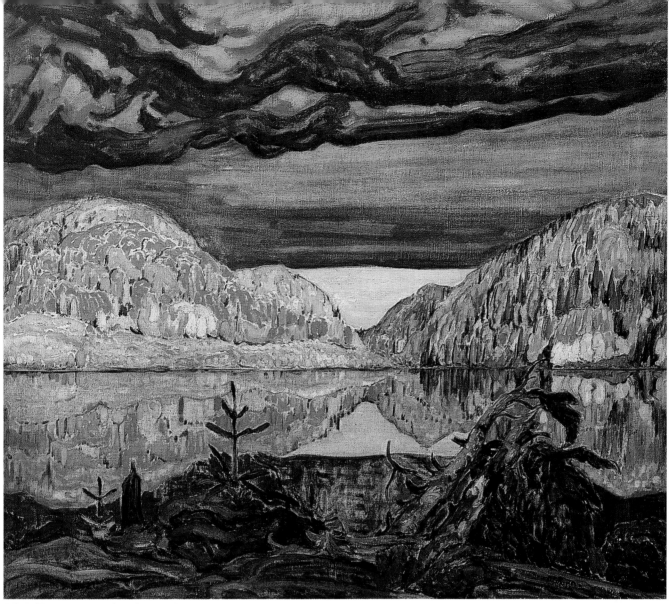

J.E.H. MACDONALD, *October Shower Gleam,* 1922

▲ **THE ELDEST MEMBER** of the Group, J.E.H. MacDonald, was the first to take his paint box into the wilderness. He and Lawren Harris became friends, and in 1912 they travelled together to Buffalo, New York, where they saw an impressive exhibition of Scandinavian art that offered a parallel vision of what MacDonald called the "mystic north."

▶ **AS AN APPRENTICE** to Franklin Carmichael in a commerical art studio, A.J. Casson was gradually drawn into the Group's circle, becoming a full-fledged member only in 1926. He lived until 1998. In the years after the Group disbanded, Casson went on to develop a clean, clear modern style of his own.

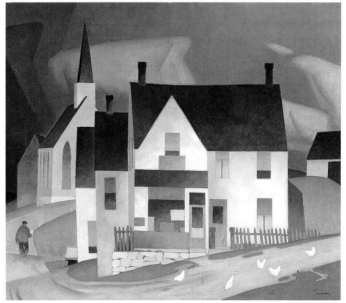

A.J. CASSON, *Country Store,* 1945

In a Modern Landscape

As the Group of Seven forged a northern vision of an untamed Canadian landscape, other artists pursued independent paths outside of the Group's influence. In most cases, these other artists painted more settled landscapes. Whether farm lands, cities, or cottage country, their choice of subjects reflected emerging 20th-century Canadian realities as pioneering and settlement eras passed. In these landscapes there is a changing focus. They show the beginnings of a modern look to Canadian art, a look underpinned by a more abstract imagery that portrays essential, elemental forms. We also see the emergence of subjective, psychological points of view in the art.

▶ **PAISLEY, ONTARIO**, was the birthplace of painter David Milne, but he found his first success in New York, where he went as a young man to work as an illustrator. Milne exhibited in the famous Armory Show of 1913, the same exhibition in which the French artist Marcel Duchamp showed his scandalous upside-down urinal. Milne's enthusiasms embraced Impressionism and the modern style that Matisse had pioneered. For a time he lived in upstate New York, in a hamlet named Boston Corners, where he developed an understated style that owes much to the simple but elegant watercolours that he often painted. During World War I, Milne enlisted in the Canadian army. He served in England and France as one of the first official war artists. He returned permanently to Canada in 1929 and worked in Ontario until his death in 1953. He left behind a uniquely poetic interpretation of the landscape.

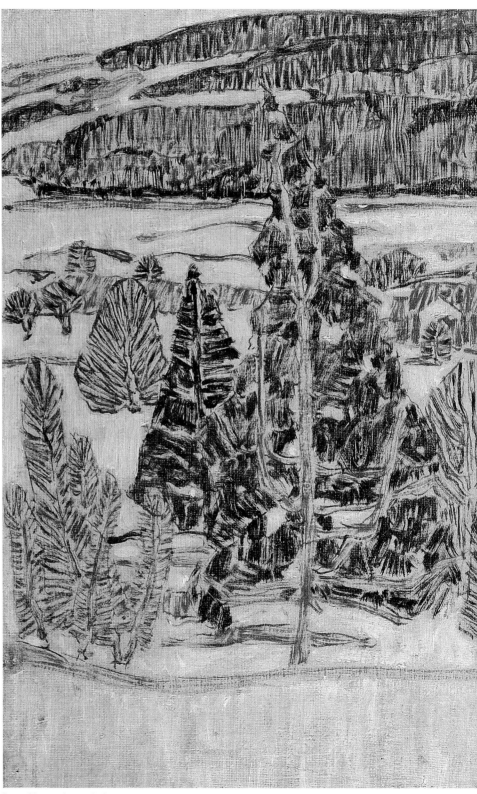

DAVID MILNE, *Green Cedars*, 1920

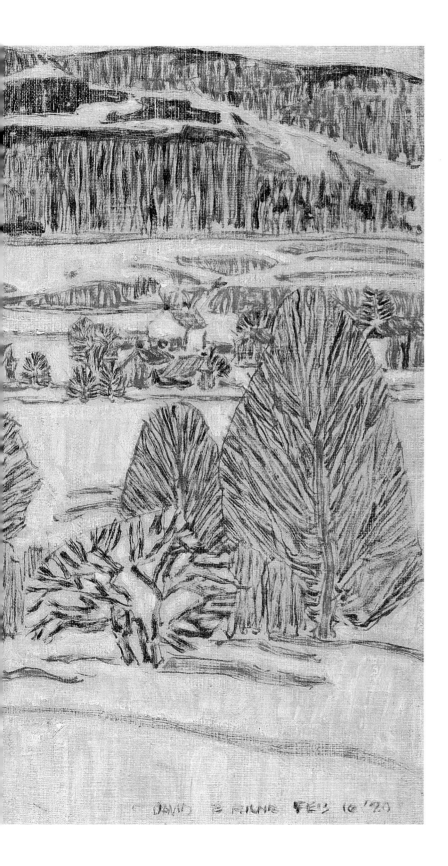

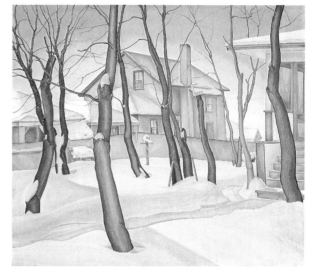

L.L. FITZGERALD, *Doc Snyder's House*, 1931

▲ **LIONEL LEMOINE** FitzGerald lived in Winnipeg, and although he showed with the Group of Seven, he remained an isolated loner. His paintings are calm and quiet and vibrate with subtle geometries. Here the homes, painted in small, fine brushstrokes, seem to shelter the bare trees.

▼ **THE DRAMA** of a low, brooding sky over a sunlit field brings to mind the Dutch painter Vincent Van Gogh. Carl Schaefer studied with Lismer and MacDonald, but his pictures are more emotional than theirs, as we see in the stark, troubled contrasts here.

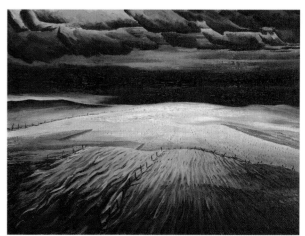

CARL SCHAEFER, *Storm Over the Fields*, 1937

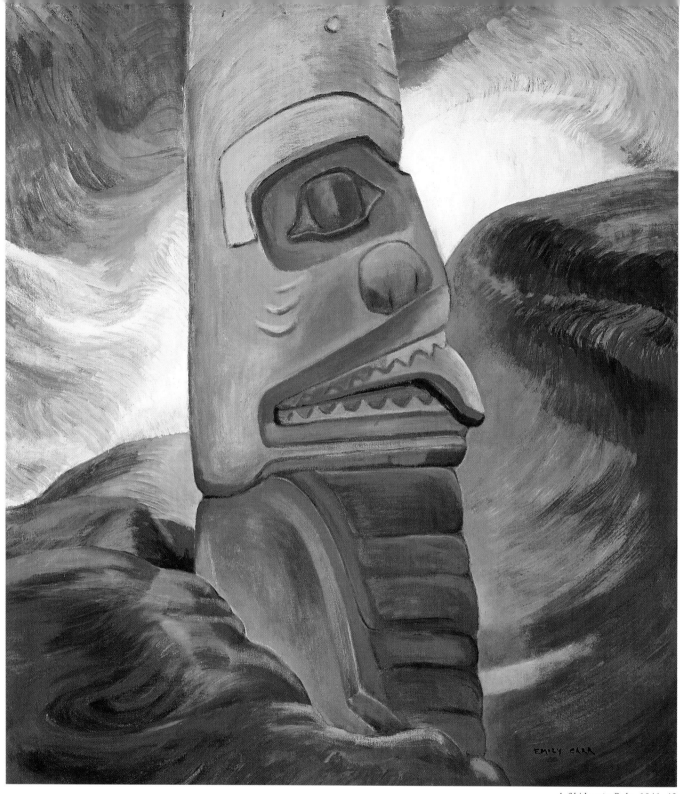

A Skidegate Pole, 1941–42

Emily Carr

She was born in Victoria in 1871, the youngest of five daughters. After troubled adolescent years and the early death of her mother, Emily Carr studied art in San Francisco and then pursued further studies in England and France. For years, she taught children's art classes and eked out a quiet, scarce living. In her fifties, she blossomed as an artist and began to receive critical recognition. Towards the end of her life, Carr published a number of books, one of which, *Klee Wyck*, won a Governor General's Award. She died in March 1945.

▶ **CARR CARRIED** out an intense correspondence on the spiritual dimensions of art with the Group of Seven painter Lawren Harris during the late 1920s. Harris's growing influence can be seen in the more abstract direction that Carr began to take in her work. During the 1930s, her paintings became more loose and free. The brushwork swirls in search of primal energy, and a limitless light—sometimes blue, sometimes white—shines in her pictures.

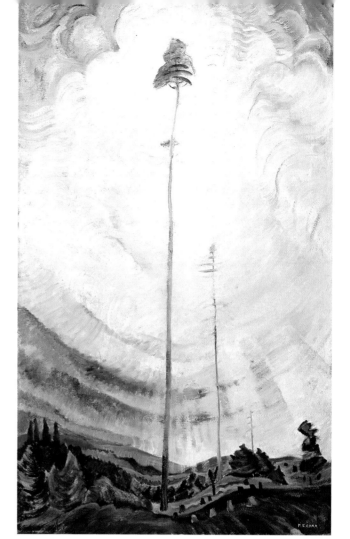

Scorned as Timber, Beloved of the Sky, 1935

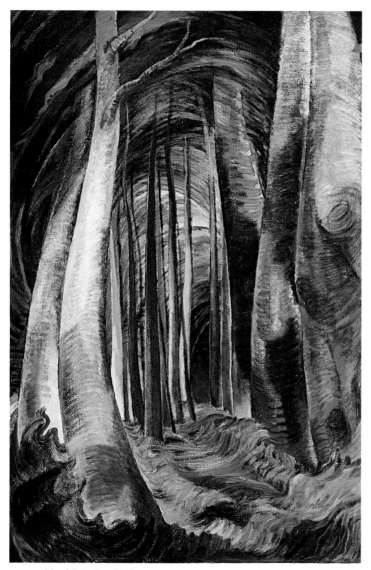

Wood Interior, 1935

▲ "**WORKING ON JUNGLE**…nobody goes there….The loneliness repels them, the density, the unsafe footing, the dank smells, the great quiet, the mystery…," wrote Carr in her book *Hundreds and Thousands*. Her choice of words reflects the age-old symbolic life of forests as dark and dangerous places. But a forest can also be a refuge, and never more so than in this remarkable painting. It shows a cathedral-like clearing where carpets of moss roll like rumpled bedding between the towering tree trunks.

▼ **NATIVE CULTURE** was at the centre of Carr's early works. From 1898, she began making trips into settlements on Vancouver Island and elsewhere, and she saw a great Northwest Coast Indian culture in forlorn decline. With drawings, watercolours, and oil sketches, Carr captured impressions of the people, their villages, and their monumental carved totem poles and war canoes. In these early paintings, she looks from a distance. Later in her career, she returned to the same subjects, only to show them close up and animated with pulsing psychological energy.

Tanoo, Queen Charlotte Islands, 1913

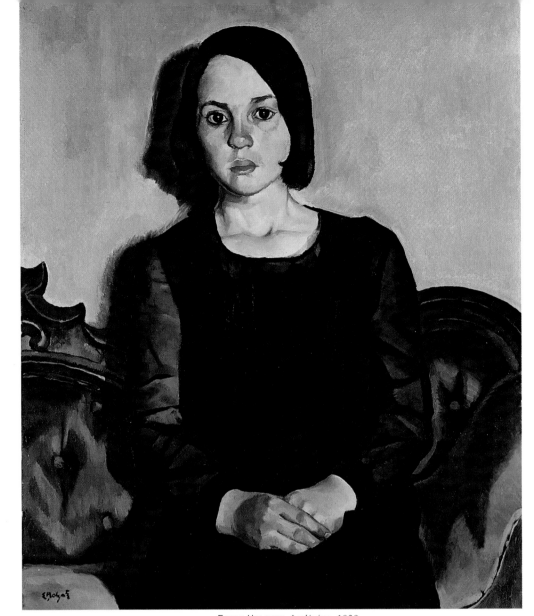

Montreal and Toronto were large, bustling cities in the 1920s, and urban subjects came to occupy many artists. Portrait painting, in particular, enjoyed a resurgence. While the Group of Seven showed the land, these city painters showed who lived there. Battles erupted over artistic styles and the dominance of the Group of Seven, which gave preference to landscape painting. In time, however, broader tastes began to shape the art scene. Writing in 1932, the painter John Lyman argued that "the real adventure takes place in the sensibility and imagination of the individual. The real trail must be blazed towards a perception of the universal relations that are part of every parcel of creation, not towards the Arctic Circle."

EDWIN HOLGATE, *Ludivine*, 1930

The Modern
Portrait

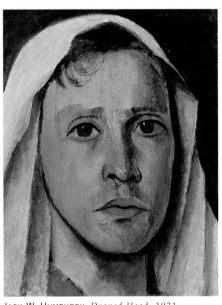

▶ **THE FACE** is the artist's, and he brings it close to us. There is no room to stand back, no telling details to flesh out the scene. The draped head is timeless. He could be a biblical figure, except that we recognize the inquiring directness of his gaze as a more modern look. Raised in Saint John, New Brunswick, Jack Humphrey studied in Boston, New York, and Europe before settling again in the Maritimes.

JACK W. HUMPHREY, *Draped Head*, 1931

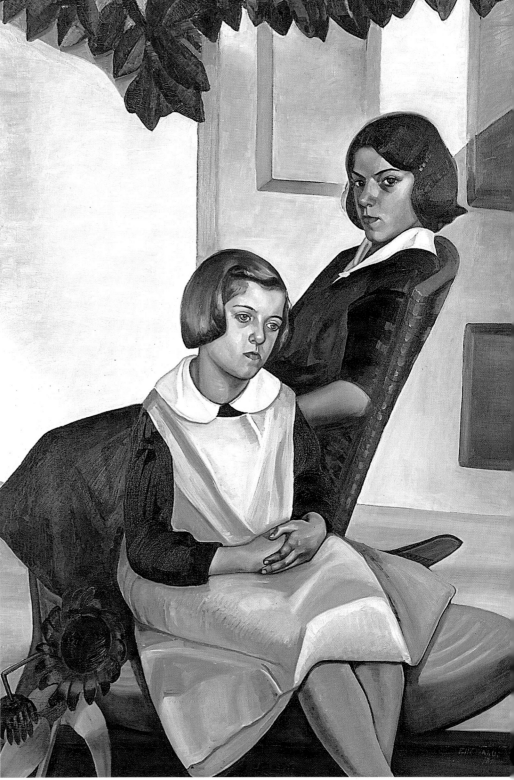

◀ **COLD DAYLIGHT** fills this 1930 portrait to create a crisp, dark shadow of the young woman's head against the wall. It is winter light, northern light. Its rendering connects Edwin Holgate's painting to the Group of Seven and their efforts to define the terms of a Canadian art. But where the Group looked to the land, Holgate finds its light. He uses it to spotlight his interior setting. The couch speaks tradition, and the young woman's clothes conservative taste. The light is a light without warmth. Together, they knit the sitter's wary demeanour into an image of youth and vulnerability.

JOHN LYMAN, *Woman with a White Collar,* 1936

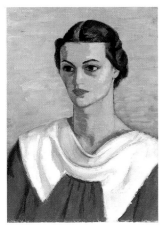

▲ **A LONG, EVENTFUL** life in art was in store for John Lyman when he left for France to study in the early 1900s. Briefly a student of Matisse's, he worked in Paris until returning to Canada in 1931. Lyman championed the international art values that he learned abroad and challenged the Group of Seven's wide influence by organizing a competing group, the Contemporary Arts Society. In his battle with the idea of a national art, he took up his pen and became an influential newspaper art critic.

PRUDENCE HEWARD, *The Sisters of Rural Quebec,* 1930

▲ **NAMED AFTER** the address of their shared studio space, a loose association of Montreal painters called themselves the Beaver Hall Hill Group. Throughout the 1920s, the artists would gather in the studio to paint hired models and hold their art exhibitions. A number of the most notable Beaver Hall Hill artists were women. Prudence Heward, in particular, created an individual modern style. Her favouring of crisp, angular lines and harsh-lit darkening colours brings a disquieting mood of troubled anxiousness to her paintings.

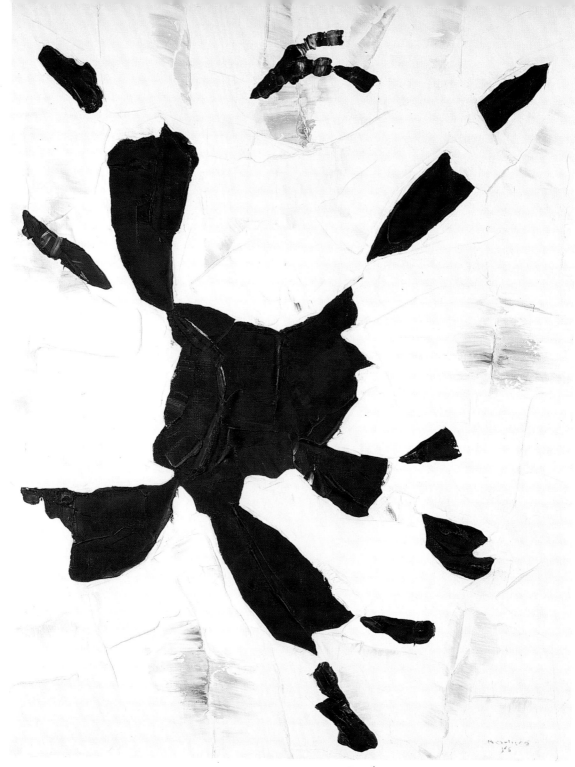

PAUL-ÉMILE BORDUAS, *Expansion rayonnante*, 1956

Borduas
+ Quebec
Abstraction

Paul-Émile Borduas trained traditionally under Ozias Leduc. His earliest paintings were of natural subjects, but by the 1940s Borduas was committed to abstract art. He led a group known as the Automatistes, who aimed to modernize Quebec art and catch up with international trends. His statement of artistic aims, the *Refus global*, inspired younger Quebec artists, but it also cost him his job teaching at a Montreal art school. He moved to New York, then Paris, where he died in 1960.

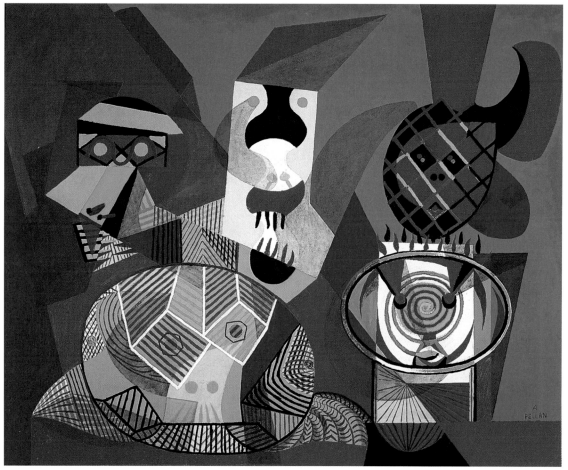

ALFRED PELLAN, *Mascarade*, 1942

JEAN-PAUL RIOPELLE, *Coups sur coups*, 1953

▲ **ALFRED PELLAN** was a gifted painter. He won a scholarship to Paris and built a career there, working in the cubist style of Picasso and Miró. When World War II forced him back to Quebec in 1940, he returned an international art star. Together, he and Borduas led the modernist cause there. However, as artists, they were too competitive to be close. By the 1950s, they came to represent opposite camps. Pellan was the conservative; Borduas the radical.

◀ **JEAN-PAUL RIOPELLE** also signed the *Refus global* manifesto. He was a student of Borduas's, and like his teacher, he explored new ways of making paintings. Riopelle uses palette knives to apply his paint, laying down thick swatches of colour in radiating bands. He has gained an international reputation for his work.

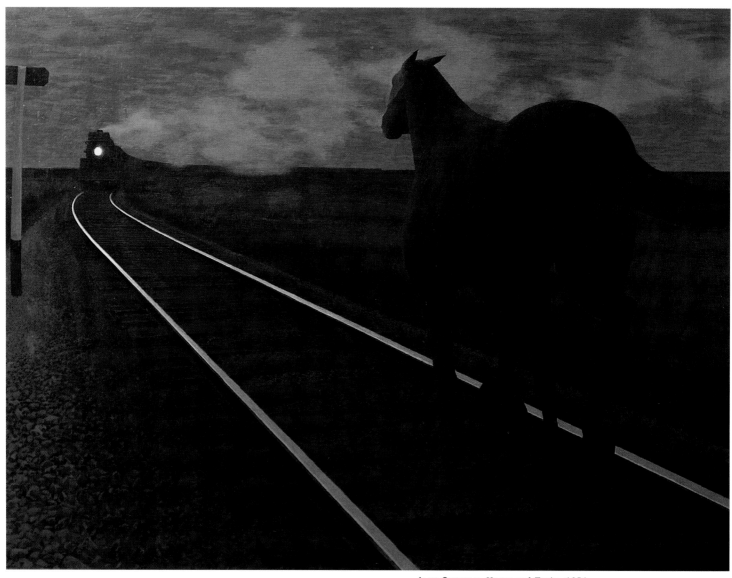

ALEX COLVILLE, *Horse and Train, 1954*

Cold War
Realism

The Cold War lasted from the end of World War II until the early 1990s, and shaped most aspects of life in North America and Europe. The tensions and anxiety of the possibility of an annihilating nuclear war lay beneath the surface of daily life. In art, these tensions gave renewed energy to painting that affirmed traditional realism and the look of everyday things. Capturing appearances became a way to preserve and safeguard them. The paintings, however, return again and again to percolating themes of fear.

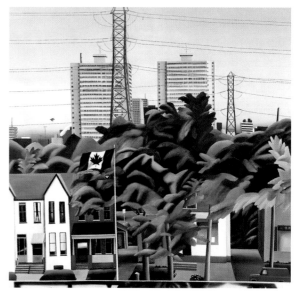

CHRISTIANE PFLUG, *Cottingham School with Black Flag, 1971*

◄ **OMINOUS TENSION** snaps along the rails between the black horse and oncoming train in one of Alex Colville's most famous paintings. The 1954 work pits an animal against a relentless machine. It seems as if an earlier time is poised to smash against a newer one. In composing his painting, Colville casts the viewer's lot with the racing horse. We see the scene from its perspective and register its vulnerability as our own. Stark, unsettling contrasts are common in the artist's work. For more than fifty years, he has created a series of memorable images and been called Canada's painter laureate. Beginning his career as a war artist, Colville was one of the first to witness Nazi concentration camps as they were liberated at the end of World War II. The precarious mortality that pervades his paintings has been a constant. He continues to work from his home studio in Wolfeville, Nova Scotia.

▶ **METICULOUSLY PAINTED** in subdued colours, Christopher Pratt's rendering of a room interior has an eerie sense of isolation from the shining light outside the window. Based in Newfoundland, Pratt worked as a young artist with Colville at Mount Allison University in New Brunswick. His paintings often show houses or cityscapes, and all possess a calm, geometric order. Each picture is planned on a square grid, then exactingly drawn with mathematical calculations. The clean, classic results are tuned to emptiness.

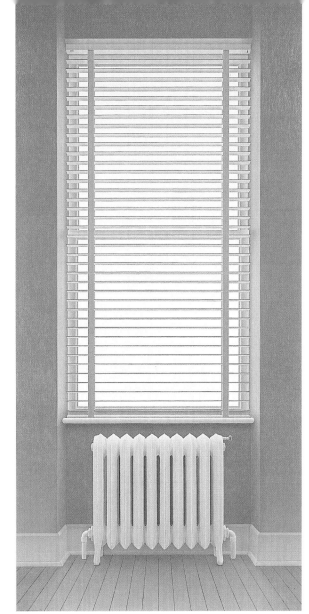

CHRISTOPHER PRATT, *Window with a Blind*, 1970

▶ **HIS CHILDREN'S** books, such as *A Prairie Boy's Winter* and *A Prairie Boy's Summer*, made William Kurelek a familiar name across the country. In his paintings, Kurelek turned to more disquieting subjects. Symbolic details fill his landscapes. Here a billowing cloud that hovers on the horizon reads as if it was from a nuclear explosion.

◄ **AFTER IMMIGRATING** to Canada from Germany in 1959, Christiane Pflug settled in Toronto and began to make many pictures of her young family and new city. Often painting views through her windows, she sometimes produced troubled images that have a foreboding sense of disorder.

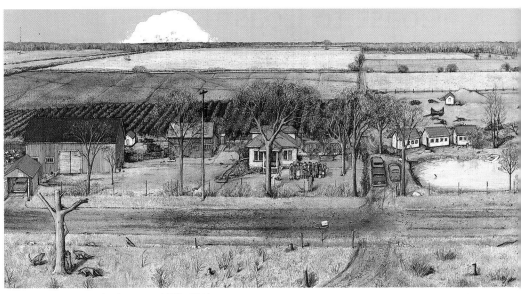

WILLIAM KURELEK, *In the Autumn of Life*, 1964

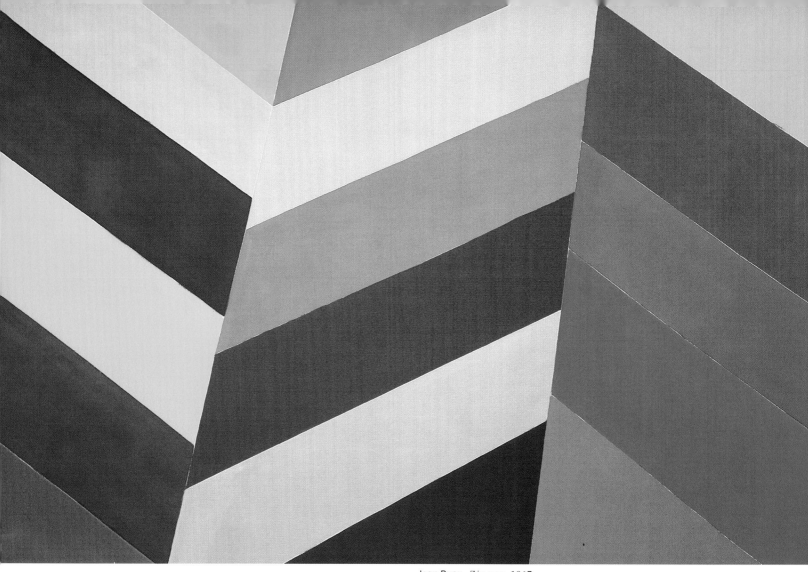

JACK BUSH, *Zig-zag*, 1967

Colour
Coast to Coast

By the 1960s, abstractionism had taken hold of the Canadian art scene. It was a time of international awareness, culminating in Expo 67 in Montreal, which was part of the celebrations for Canada's 100th birthday. Modern art was the same age, and the new colour painting, often on large-size canvases, seemed to be its celebration. It was an art of pleasure that emphasised looking, seeing, and living in the present. Abstract painting explored its own space, making it a modern variation of landscape painting.

JACK SHADBOLT, *Northern Elegy #2*, 1964

▲ **TRADITION SHAPED** the paintings of B.C. artist Jack Shadbolt, who studied with the Group of Seven's Frederick Varley. Shadboldt embraced many styles, and all were linked to nature. Here the stripes rise to what seems a horizon line.

◀ **SWITCHING TO** acrylic paints in 1965 was a way for the Toronto artist Jack Bush to gain intensity for the wide range of colours he used in his paintings. As one of the Painters Eleven group in Toronto in the 1950s, Bush first painted in a loose expressionist style, but he left it behind. His enthusiasm for Matisse led him to explore playful interactions of colour for its own sake.

▶ **PERCEPTION IS** everything in the work of Montreal's Guido Molinari. He organizes stripes and repeating colours into careful sequences that create elegant, rippling rhythms. With simple geometric elements like these, Molinari's paintings link abstraction back to the timeless ideas of order and beauty in early Western art.

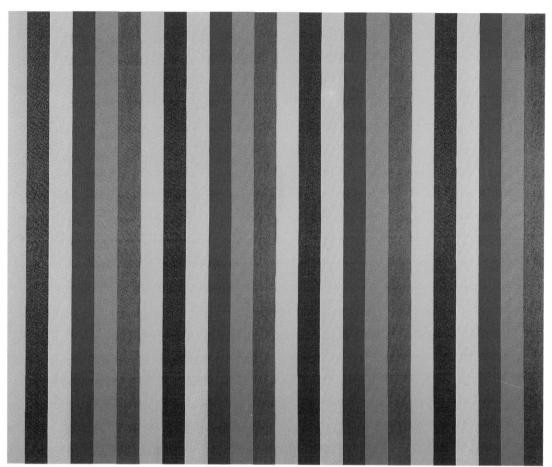

GUIDO MOLINARI, *Mutation Serielle Verte-Rouge,* 1966

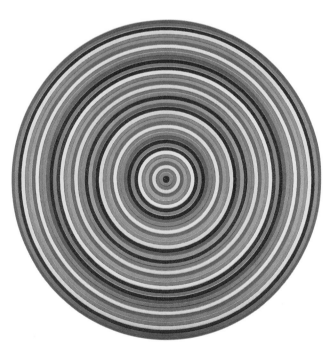

CLAUDE TOUSIGNANT, *Gong 88,* 1967

▲ **CIRCLES PULSE** with colour in Claude Tousignant's art. In 1965, he started to make round canvases whose target shape gave him a ready-made composition. His goal, he said, was to create paintings that had no "extraneous matter."

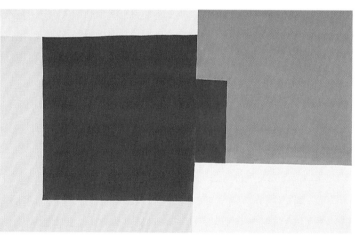

KENNETH LOCHHEAD, *Purple Emphasis,* 1967

▲ **IN REGINA** in the early 1960s, Kenneth Lochhead participated in a National Gallery touring exhibition called "Five Painters from Regina." The name Regina Five stuck. The group included Lochhead, Arthur McKay, Ronald Bloore, Ted Godwin, and Douglas Morton. As a teacher, Lochhead helped establish annual workshops at Emma Lake, Saskatchewan. Each August, important people in the art world visited and lectured. Here, the New York artist Barnett Newman and the critic Clement Greenberg advised making this more simplified abstract art.

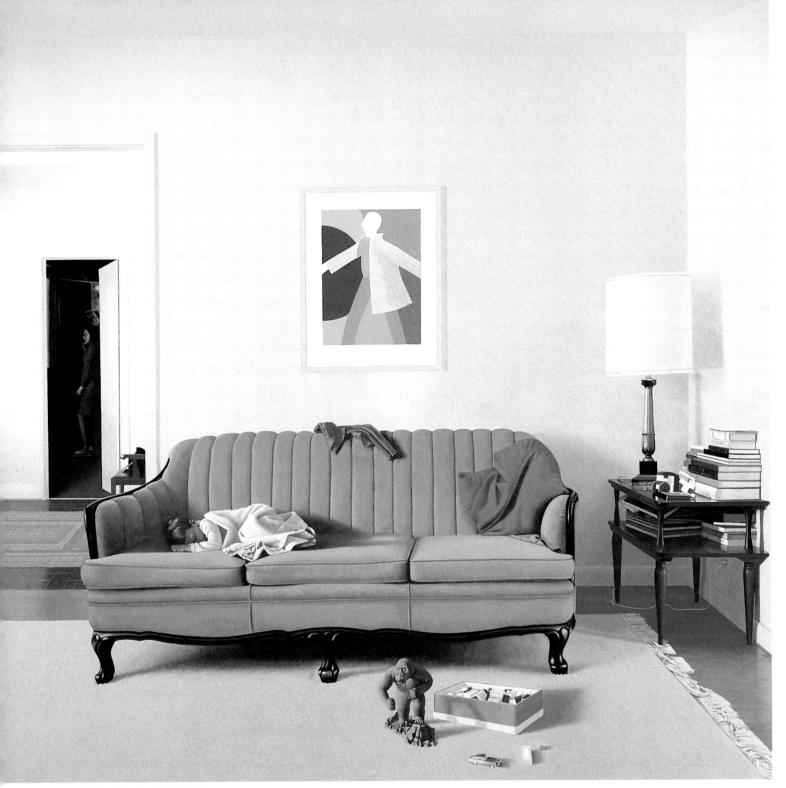

Diego Sleeping No. 2, 1971

Victoria Hospital, 1969–70

▲ **THE IDEA** of home was important to Chambers. The subjects for his paintings were always close at hand. He also once made a film called *Circle*, which showed—a few seconds at a time over the course of an entire year— the view from his kitchen window. In the painting above, he shows his young son sleeping on the living-room couch, with the mother seen through the open doorway. The picture of the striding man was a painting made by Chambers' friend and fellow London artist, Greg Curnoe. Even the wide landscape to the right has a personal reference point. The building in the distance that breaks the horizon is the hospital where Chambers went for treatment of his illness.

Jack Chambers

Painter Jack Chambers was born in London, Ontario, in 1931. At the age of twenty-two, after attending the local technical school, he left for Europe, where he studied at the Royal Academy of Fine Arts in Madrid, Spain. Chambers returned to London in 1961, and for several years experimented with different painting styles before he developed an approach that he called perceptual realism. The term comes from the title of an influential essay that he wrote for *Arts Canada* magazine in 1969. The style relied on photographic images, and it was one that Chambers practised for ten years, until his early death from leukemia in 1978.

▶ **"EVERYTHING AND** anything that one *sees* is…more than we can understand it to be." This statement is drawn from Chambers's published essay "Perceptual Realism," and is at the root of his art. For Chambers, local scenes held a deep fullness to be explored by the act of painting. Here a simple view across the street from his house becomes a testimony of wonder at seeing two different cars in the driveway in front of two different pine trees.

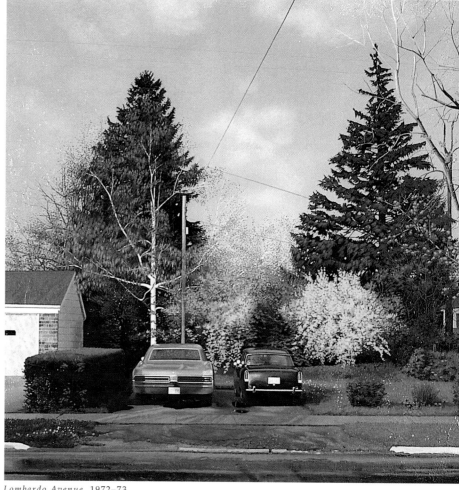

Lombardo Avenue, 1972–73

401 towards London No. 1, 1968–69

◀ **PHOTOGRAPHS** were important sources for Chambers's late paintings. After selecting one of his own snapshots, he would overlay it with a grid of half-inch squares and then meticulously transpose them onto canvas, matching tone for tone until he felt he had rendered his original experience of the scene. In this painting of the main highway between Toronto and London, the tilt of the land, the leading edge of the clouds, and the vanishing curves of the road present a sense of movement through open space.

AN ORANGE BORDER, BELOW THAT "RVI
CE L MP", WHITE LETTERING, BODONI, F
OLLOWED BY A WHITE DIAMOND, BELOW
THAT ON DARK BLUE. BELOW THAT, SMA
LLER LETTERING, SAME STYLE, DARK BL
UE "CO. LIMITED", ON WHITE. UNDER THA
T IS A THIN ORANGE LINE. THE SIGN IS
LIT FROM ABOVE BY 4. LAMPS WITH GR
EEN SHADES. ABOVE IT, 5. WINDOWS, 2½
PAIRS, WITH WHITE FRAMES. AN ORAN
GE FLAG FLAPS OVER 2. OF THEM. ABOV
E THE RIGHT HAND PAIR ARE GREY SIL
LS & ABOVE THEM A CIRCULAR DEPRES
SION IN THE RED BRICK WITH GREY CO
NCRETE BLOCKS SET IN THE CIRCLE A
T 12,3,6 &9 O'CLOCK. TO THE RIGHT IS A
GREY DIAMOND & ABOVE — THE ORNATE
ROOF LINE, PAINTED WHITE. TO RIGHT
THE R LEFT WALL OF GUILD HOME EO
UIPMENT RECEDES. ←! THE SKY IS OVER
CAST. BELOW THE SIGN,197 ON THE GL
ASS ABOVE THE DOUBLE DOORS.

GREG CURNOE, *Cityscapes: Right Windows,* 1967

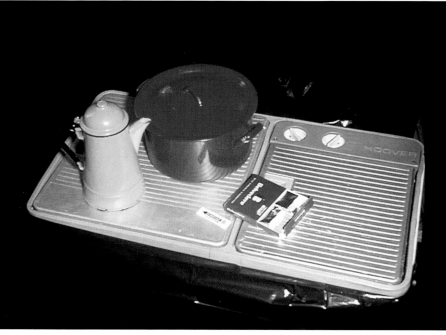

MURRAY FAVRO, *Washing Machine*, 1970

London
Calling

The Southern Ontario city of London is not large, but it has played an important role in Canadian art. Artists like Jack Chambers and Greg Curnoe made decisions to work and raise their families in London rather than move to larger cities like Toronto or centres like New York. They made their art from the views through their windows, their home appliances, and their local weather. They celebrated place and the richness to be found within it.

◄ **THE WORDS** make the picture in this "stamp" painting by Greg Curnoe, a leading figure of the London art scene until his death in 1992. Curnoe, a Canadian nationalist, believed local subjects and experience were the hallmarks of important art.

▲ **LOOK CLOSELY** and you will see things are not what they seem. Murray Favro has made a sculpture where a projected slide provides the colour and creates the illusion of reality. In other projects, he built a scaled-down jet plane and a train engine on a tapering railway track. In each case, the sculptures raised questions about our readiness to accept appearances over facts.

◄ **A MOVE** to London from Montreal brought changes to Paterson Ewen's painting. He began to work on large sheets of plywood, gouging them and adding metal shapes that translated his weather themes into forceful physical presences.

► **SIMPLE STARTS** bring complex results in Ron Martin's work. Here he begins by pouring sky blue paint onto a canvas and then smearing it round and round until it spreads to the edges with subtle variations of the colour. The result is a woven, nest-like space that summons ideas of arriving at the core of something.

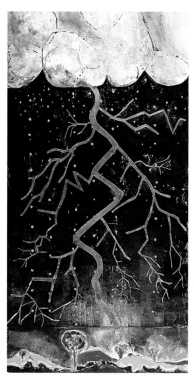

PATERSON EWEN, *Forked Lightning*, 1971

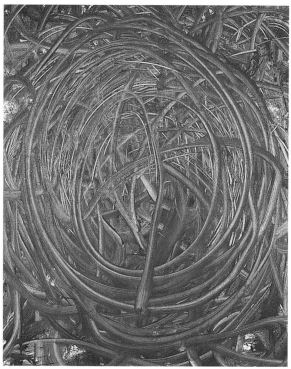

RON MARTIN, *Cerulean Blue*, 1971

Joyce Wieland

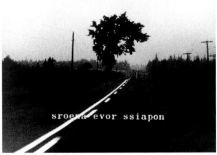

I think of Canada as female," Joyce Wieland once said, outlining the two themes that defined her art. A painter and filmmaker, Wieland began her career in Toronto, moved to New York, then returned to Toronto to finish her career. As she explored feminism and political and ecological issues in her work, she became a role model for younger artists, younger women artists in particular. Wieland often questioned American dominance of the Canadian cultural scene. With her tongue in her cheek, she said she favoured nationalism—but only for "weak countries" (where it would have no negative effect). Her sense of humour extended into the art she made. When she had a major exhibition at Ottawa's National Gallery in 1971, she titled her show "True Patriot Love" and scheduled its opening for Canada Day. She wanted, she said, "to give the people of Canada a sense of themselves."

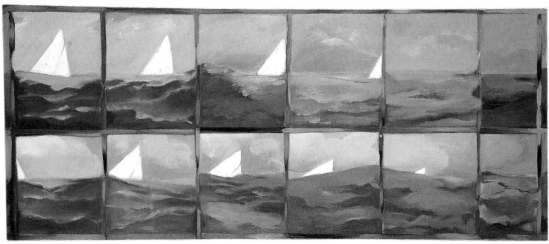

Boat Tragedy, 1964

▲ **WIELAND BEGAN** making energetic abstract paintings. Their rich colours and soft contours traced themes about the body. In the 1960s, however, she put abstraction behind and returned to her training in animation. She made paintings divided into cartoon frames. The storyboard layouts showed boats sinking and planes crashing, disaster themes that came to her after the assassination of U.S. president John F. Kennedy. Shortly after, she moved from painting storyboards to making actual films.

From the film *Reason over Passion*, 1967-69

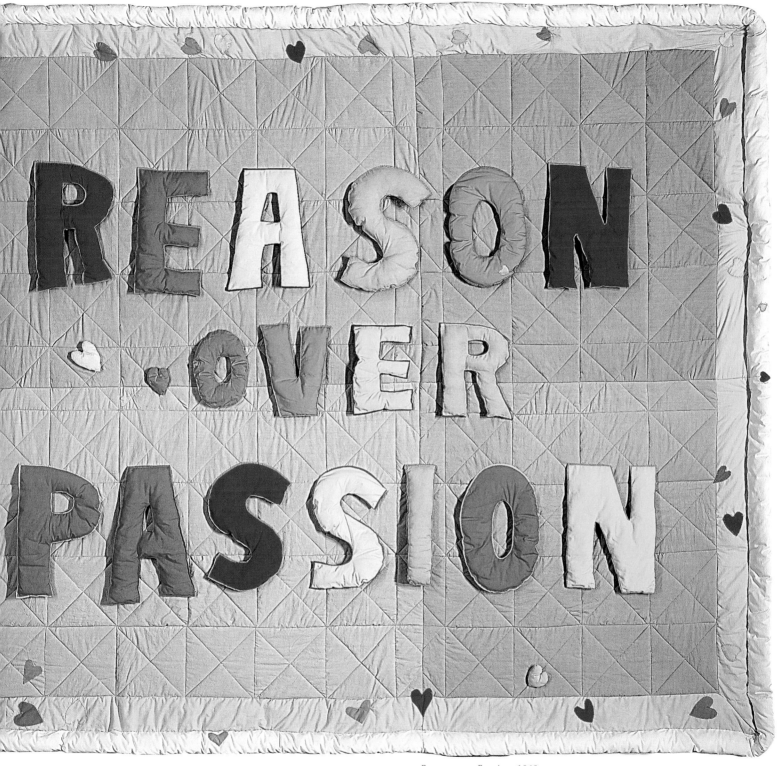

Reason over Passion, 1968

◄ **TRANSLATE "SSIAPON"** as "passion." In her film *Reason over Passion*, Wieland resurrected the Canadian landscape. The film shows landscape views across the country as the letters in "reason over passion" go through their various permutations. The only missing locale is Ontario. It is replaced by the face of Prime Minister Pierre Elliot Trudeau.

▲ **CRAFTS AND QUILT-MAKING** proved to be the sources of a new dimension in Wieland's art. Because of their associations with the traditions of "women's work," the quilts served as a foundation for feminist art. In the one shown here, which carries the same title as her film, Trudeau's famous phrase is given a playful new context that softens his words.

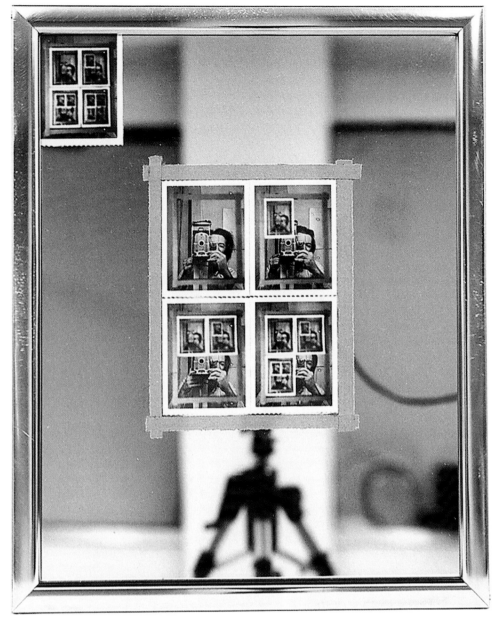

Authorization, 1969

From the film *Wavelength*, 1967

▲ **FILM WORKS** have made Michael Snow famous. His international reputation began to grow after the release of *Wavelength*, a film where the camera zooms slowly forward through a studio space for 45 minutes, making an intense, original type of mystery movie.

◄ **PHOTOGRAPHY** has also been a key for Snow. In *Authorization*, he creates a complex visual puzzle with Polaroid images taped in sequence to a mirror, covering over the camera that took the pictures.

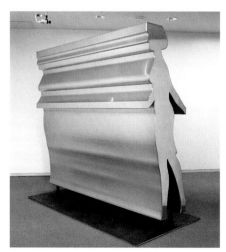

Expo Walking Woman: Stretched Figure, 1967

Michael
Snow

One of Canada's most versatile artists, Michael Snow has been based in Toronto for much of his long career. However, after making a start in both painting and sculpture, he moved to New York in the 1960s. There he began work on his influential experimental films. In the films, programmed machinery or the application of mathematical systems often determine the movement of the camera. Watching them, the viewer learns new ways to see.

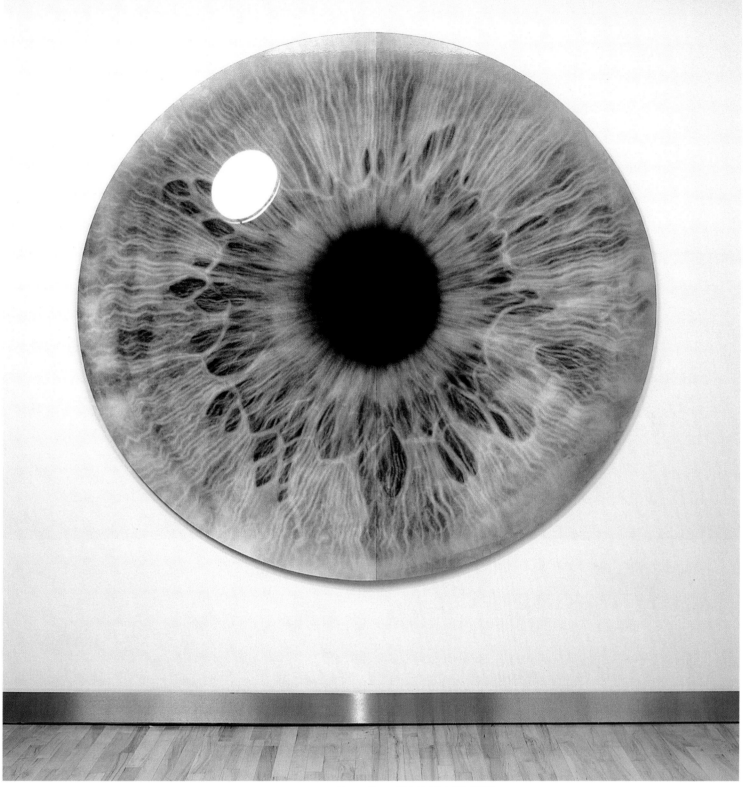

Conception of Light (detail), 1992

◄ **WALKING WOMAN** came before Snow's films. From 1961 to 1967, Snow developed paintings and sculptures from a stencil silhouette of a woman walking in profile. A number of them were installed in the Ontario pavilion at Expo 67. Their appearance amidst the crowds was playful and Snow has since made other public art, including *Flight Stop* and *The Audience*, at Toronto's Eaton Centre and SkyDome.

▲ **SEEING AND ITS PLEASURES** are essential to Snow's art. The various perceptual games have a purpose. "What I am trying to do," he once said, "is to make people see things in front of them." In the work above, this thought is made almost literal. On the wall is a vastly enlarged photograph of an eye. Across from it is another one. The two stare at each other across the room. The blue one is Snow's, the other one belongs to his wife, Peggy Gale. "The blue eye is colder, cosmic, electrical," Snow says. "The orange eye is warmer, organic, undersea, floral." Together, they fill the space with looking.

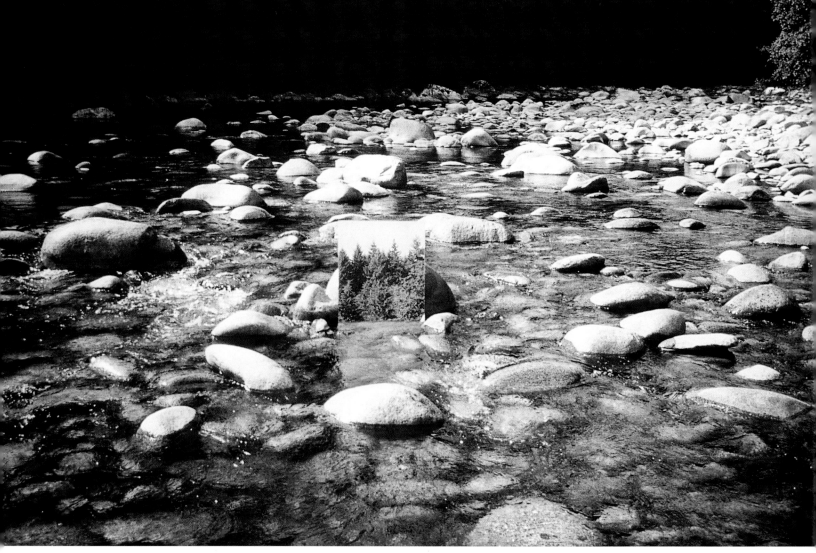

N.E. Thing Co., *Reflected Landscape*, 1968

Thinking Art

It began in the social revolutions of the 1960s, in a spirit of both adventure and self-examination. Artists turned an eye inward on their practice and their role in society. They imagined new ways of making art and new ways of reaching audiences. Called conceptual art, it made thinking more important than seeing, setting aside aesthetic traditions. In breaking down age-old categories of art, it also introduced new media from popular culture, like photography and video. Its ideas continue to shape and influence most contemporary art.

▶ **THE VENUE** is Piccadilly Circus in London, England, one of the richest shopping districts in the world. The art on the Spectacolor billboard in the background is a version of Toronto artist Vera Frenkel's video installation *This Is Your Messiah Speaking*. Her piece takes up the theme of consumerism. The Messiah character in the video, played by Frenkel, says, "Shop. Or Someone will shop for you."

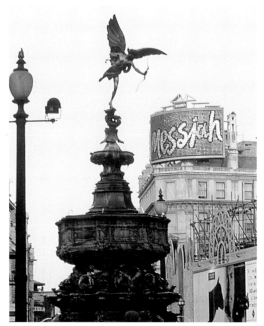

VERA FRENKEL, *This Is Your Messiah Speaking*, 1990

◄ **A GOOD NAME** goes a long way, and in the 1960s Vancouver's N.E. Thing Co. had one of the most clever names in the art world. Established by the husband-and-wife team of Iain and Ingrid Baxter, the "anything" company was an umbrella for art making. It offered a wide range of "products." This photo of pines reflected in a mirror takes its place within the great Canadian landscape tradition. It comes with a hand-tinted map of the site.

► **"PAINTING IS DEAD"** is the often-heard claim as one kind of art replaces another. For Halifax's Garry Neill Kennedy, however, painting is a subject for playful analysis. Here he follows a thread in his canvas from the top left corner to the bottom of the canvas. He then adds a layer of paint to each thread to the right of it. At the end, with the last thread painted, there are 680 layers of paint. This "system" generates the art. Its comedy is in the effort it requires.

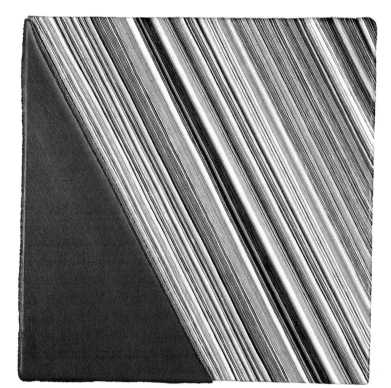

GARRY NEILL KENNEDY, *Untitled*, 1977

▼ **BELIEVE IT OR NOT**, these elegant objects started out as cooked lobsters. Calgary's Eric Cameron proceeded to cover them in layer after layer of white paint primer. In time, the layers took on a life of their own. Something new was created, which stands as a metaphor for art making.

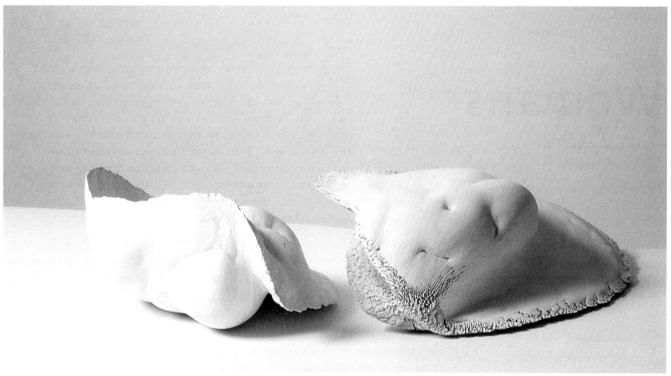

ERIC CAMERON, *Two Less Little Lobsters*, 1988

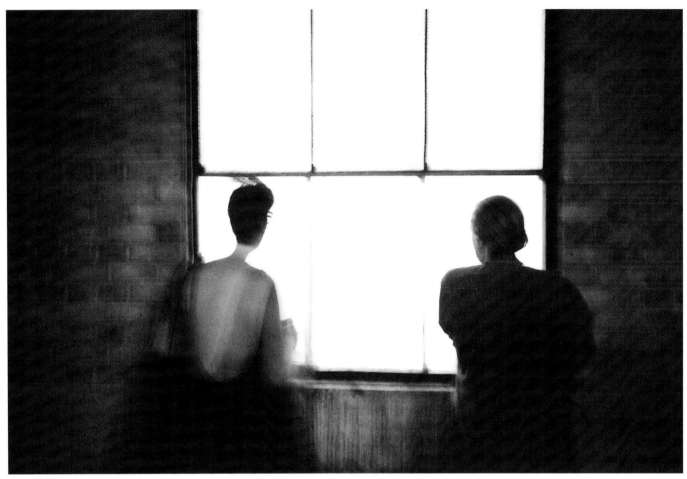

ANGELA GRAUERHOLZ, *Window*, 1988

Woman's
View

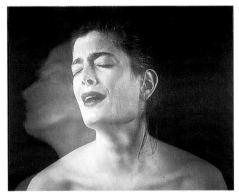

GENEVIÈVE CADIEUX, *Hear Me with Your Eyes*, 1989

At any given time, a thriving art scene offers many different kinds of art. In Montreal during the 1980s, painting, sculpture, and video art all vied for attention. However, the emergence of a powerful generation of women artists stands out. Abstract art was being replaced by a more personal art. These artists turned to intimate art forms like drawing and the newly embraced terrain of photography to explore the world of ideas and politics. The themes in their work often addressed memory or the nature of identity, themes that are related to a recognition of power and independence.

◄ **THE BLURRED** image in the background in Geneviève Cadieux's picture adds a sense of time. It is as if the woman is turning to us with her cry. The fact that she is in colour when the other two images in the room-size work are in black-and-white adds to her immediacy. The cry arrives. It becomes our responsibility, even though we can only imagine that we hear it.

◀ **TWO FRIENDS**, or so they seem, stand and look out a window in Angela Grauerholz's photograph. We can't tell what it is they see, but they see it together. The white light and the soft focus make the image look like an old photograph. All the elements come together to provide the photo with a sense of history and a feeling of individual but shared vision.

▶ **PUBLIC SPACES** and politics come together in the sculpture and installation art of Barbara Steinman. Her early works looked at subjects like Cambodian genocide and war in the Middle East. In the work shown here, the terms are more general and philosophical. She has arranged sixty lightboxes with the word "silence" along a museum hallway. As a group they stand for culture, yet they seem like a chorus subtly saying no.

◀ **FAIRY TALES** of punishment and pain are suggested by Jana Sterbak's art, which often takes the form of symbolic clothing, like this metal gown around which a burning electrical coil wraps. Sterbak has also made a wearable cocoon and a meat dress of real beef steak. With them, she links ideas of discomfort, childhood, and personal identity.

BARBARA STEINMAN, *Signs,* 1992

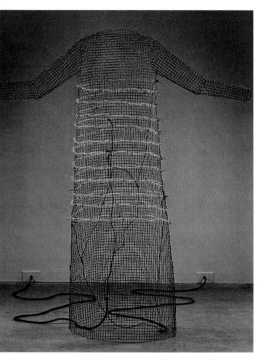

JANA STERBAK, *I Want You to Feel the Way I Do...,* 1984–85

▶ **HUMAN FIGURES** have taken different guises in Betty Goodwin's art. In the 1970s, she cut, folded, stacked, or otherwise reassembled a series of vests to suggest images of the dead and buried bodies of the Holocaust. In the 1980s, she gained her international reputation for delicate, large drawings and paintings that showed suspended human figures swimming in space and moving towards their fate. Remembering the fragility and impermanence of life is an ongoing theme in her work.

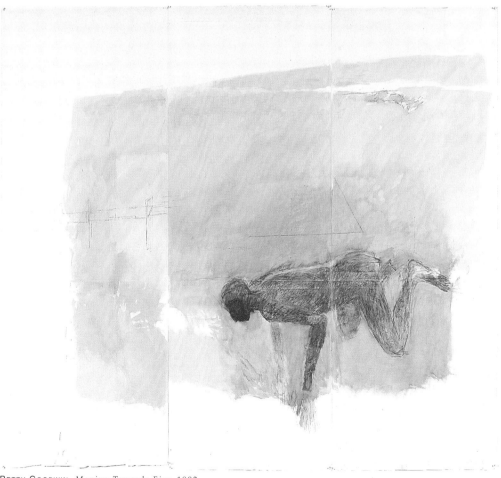

BETTY GOODWIN, *Moving Towards Fire,* 1983

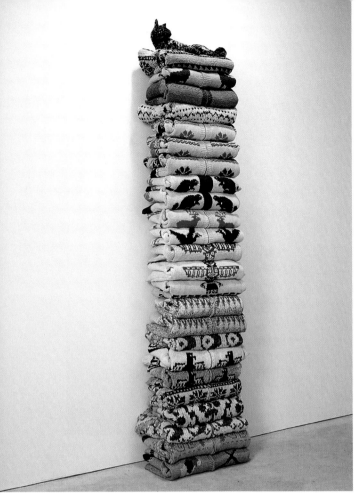

LIZ MAGOR, *Hunters' Sweaters*, 1993

Sign Systems

Canadians have made key contributions to the information age. Contemporary Canadian art has followed this lead. It often seeks to redefine ideas about what art can be. In Toronto, this has been most notable in the field of contemporary sculpture. Traditional formats like bronze casts and carved marble have disappeared in favour of objects chosen from daily life. The art balances their familiar presence with their capacity to communicate ideas about society, philosophy, history, and the burgeoning realities of media imagery. The art presumes that we live in a new world, a world where things are also signs.

▲ **UNCONVENTIONAL MATERIALS** are common in the sculpture of Liz Magor, who once made a work of art from birds' nests. In this one, she stacks traditional woollen hunters' sweaters into a Canadiana totem pole topped by a lounging cat. The references leap to West Coast native art, country clothes, animal kingdoms, domestic comfort, and woolly warmth. If we follow them through, they suggest that wilderness has gone, except for what we can buy in a store.

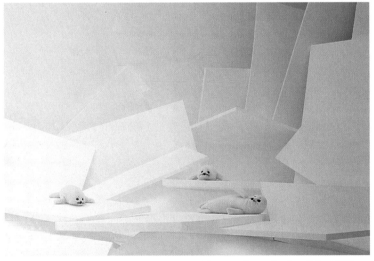

GENERAL IDEA, *fin de siècle*, 1990

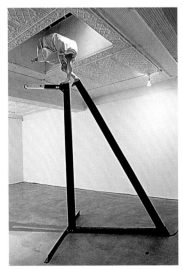

NOEL HARDING, *Lamb*, 1986

◀ **NEW TECHNOLOGY** has left its mark on contemporary art with ever-widening choices of materials for artists. Steel, plastic, electrical wiring, timers, and street light fixtures are combined by Noel Harding to make this eerie stilt figure. The glowing high-tech night lighting and the stooped, shrouded figure suggest stealth, hunting, and alarm. This lamb is perhaps a wolf.

▲ **STAGECRAFT PLAYS** its part in installation works made for galleries. In this work, General Idea created an Arctic landscape from sheets of Styrofoam. The baby seals stand for the three artists. Adrift on the ice, they have a tragicomic vulnerability. The connections are to the seal hunt, a famous German painting, and reflections on the group's fate as Canadian artists.

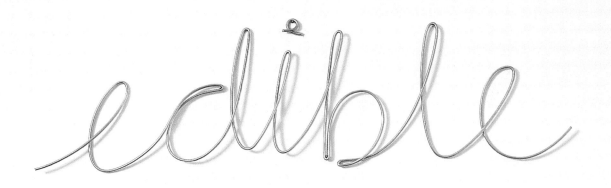

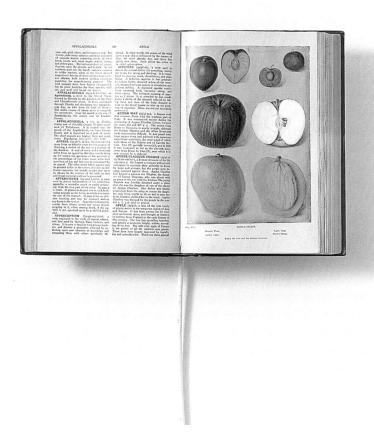

IAN CARR-HARRIS, *edible*, 1993

TOM DEAN, *Excerpts from Descriptions of the Universe* (detail), 1986

▲ **THE BOOK** is one of our most cherished objects, and here Ian Carr-Harris literally makes its association with illumination. The encyclopedia is open to a page on apples. On one side is an illustration of "edible" fruits. He has carved out the pages behind and installed a light that shines through the cut apple and heightens its colour and presence. The word "edible" is rendered in cursive writing, which raises notions of primary education. This linking of pictures, words, objects, and knowledge is Carr-Harris's core curriculum.

▶ **DOUBLE SIGNALS** make for a world gone awry in this hair hat by Tom Dean. The hat is part of Dean's *Excerpts from a Description of the Universe*, a work that featured strange sculptural objects laid out on a series of ten display tables. The effect was like a mad science fair, one where biology dominates physics and every object seems to wriggle or grow or obey only its own vital force.

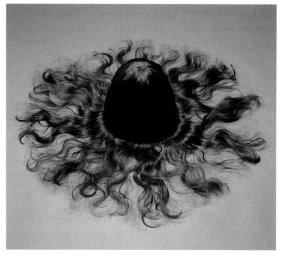

Native
Land

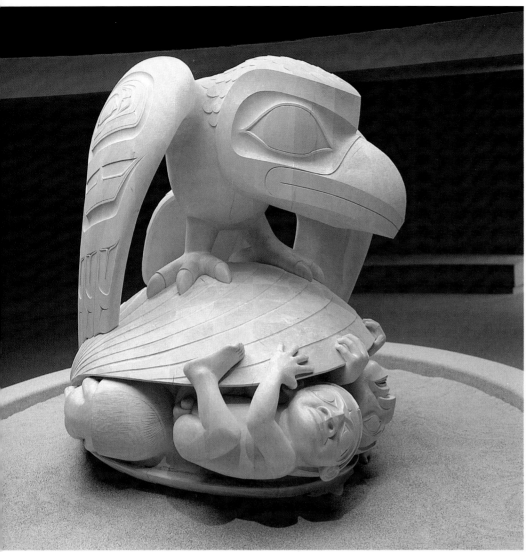

BILL REID, *Raven and the First Men*, 1980

Two generations of native artists have appeared on the Canadian art scene since the 1960s. The first generation retrieved traditional imagery for modern audiences. The second generation, which emerged in the 1980s and 1990s, makes its art from the political, social, and cultural realities of native experience. Both together have rebuilt a nearly lost ancestral history and raised awareness of how Canada's history is not always a simple story of progress.

▼ **GIVING VOICE** to a native point of view, the Ontario artist Rebecca Belmore created this human-size megaphone and took it out into a field near Banff, Alberta, where she invited thirteen participants to speak to the earth. Belmore is an installation and performance artist. Her various projects revolve around social issues and the idea of native community.

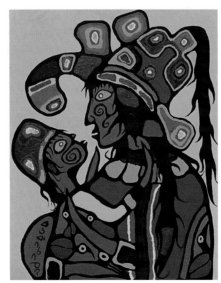

NORVAL MORRISSEAU, *Artist's Wife and Daughter*, 1975

▲ **MYTH COMES** to life as a stylized raven discovers mankind emerging from a giant clam shell in this carved cedar sculpture by Bill Reid on display at the University of British Columbia's Museum of Anthropology. Beginning in the 1960s, Reid, of Haida descent, became one of the first contemporary native artists to gain a broad public audience for his work.

◄ **LINES AND COLOURS** connect mother and child figures as inseparable partners in this painting by Norval Morrisseau. Morrisseau's art fuses traditional Ojibwa picture writing with modern abstract painting. His vibrant, stylized images are often linked to Woodland native legends.

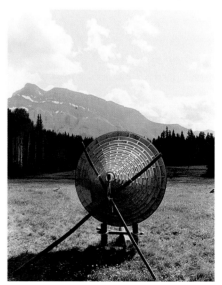

REBECCA BELMORE, *Ayum-ee-aawach Oomama-mowan: Speaking to their Mother*, 1991

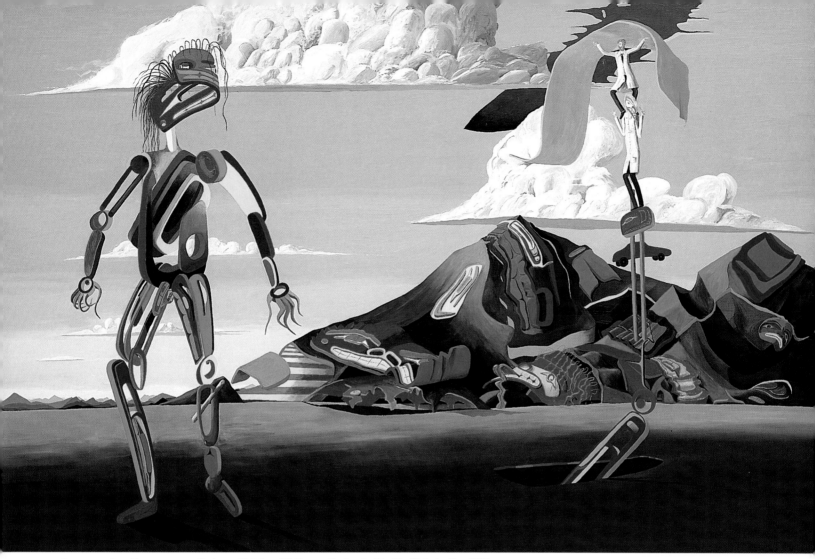

LAWRENCE PAUL YUXWELUPTUN, *Redman Watchng Whiteman Trying to Fix Big Hole in Sky,* 1990

▲ **GLOBAL CONCERNS** collide with Northwest Coast imagery in this painting by Lawrence Paul Yuxweluptun. The theme of the picture is the problem of ozone depletion in the upper atmosphere. Though the surreal scene is clearly on "native" land, the problem he shows ultimately includes us all.

◄ **POWER SYSTEMS** faced by native peoples over the past 500 years are the subjects of Carl Beam's Columbus Project. In the series, as in this painting, science, religion, reason, and idealism are seen in the darker light of native history, where they lose much of the lustre given them by Western culture. For Beam, the project retrieves a personal history from the losses of a general history.

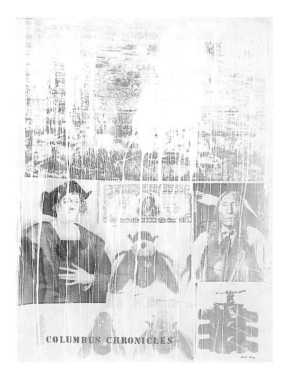

CARL BEAM, *Columbus Chronicles,* 1992

▼ **NATURE CALLS** in this work by Regina's Edward Poitras, who used the bones of seven coyotes found on the prairie to bring to life this laughing coyote. In many native cultures, the animal represents the Trickster figure. In other work, Poitras once swapped a strip of prairie grass with a strip of cut lawn to convey the idea of displacement and the often absurd reality of attempting to straddle two cultures.

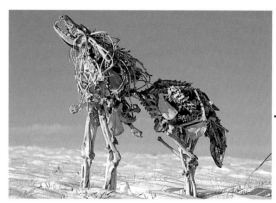

EDWARD POITRAS, *Coyote,* 1986

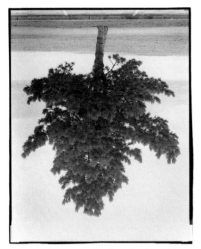

RODNEY GRAHAM, *Flanders Series*, 1989

▲ **EVERY PHOTOGRAPHER** who works with a large-format camera will recognize Rodney Graham's upside-down tree as the view they would see in their camera's viewfinder. By presenting his photograph in this seemingly upside-down way, Graham emphasizes the act of photographing over the act of seeing. The disorientation points out the subtle strangeness involved in photography's once-removed relationship with reality.

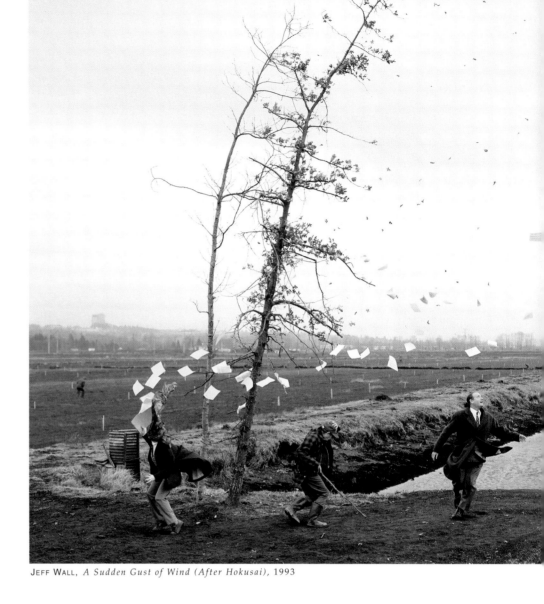

JEFF WALL, *A Sudden Gust of Wind (After Hokusai)*, 1993

Picture Land

Sometimes nicknamed Lotus Land for its warm, amenable weather, the West Coast of Canada has also in recent years been a centre for artists who have had an important influence on the international art world. With their large-format photographic works, the members of this Vancouver School have made a place for photography at the heart of contemporary art. Drawing on traditions of painting and the history of photography, their work is a reflection on our culture's pervasive use of photography. In their various ways, the artists direct our attention to the reality we face living in a world of images.

▲ **TO SEE THIS** Jeff Wall artwork only in a book is to miss some of its vibrant presence as an object. The work is a large-scale lightbox—the kind that advertisers use in outdoor advertising. In an art gallery, the image glows and casts its own light in the room. The artwork seems as much a sculpture as a photograph. It, and others like it, have given Wall a wide reputation for having created a new kind of art form. With his images, he often recalls historical artworks. This one mirrors a famous image by the traditional Japanese print artist Hokusai. Wall knits our remembrance of the earlier artwork into a new fabric of meaning—in this case, revolving around local history and the politics of land development in British Columbia.

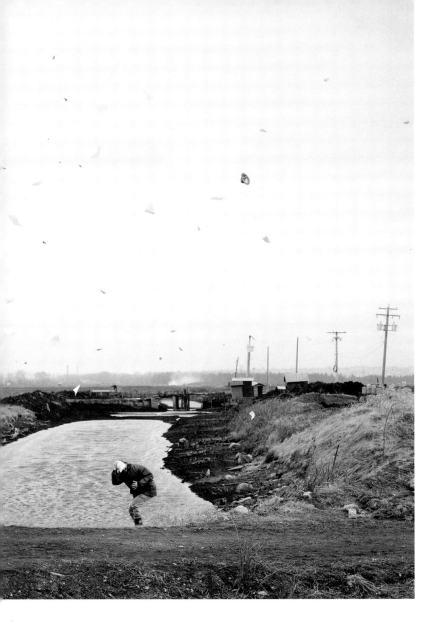

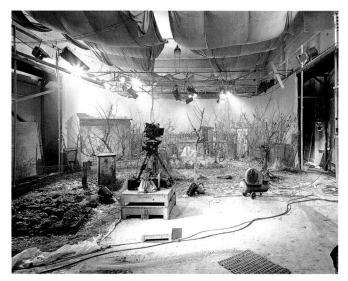

STAN DOUGLAS, *1970s Set for* Der Sandmann, 1994–97

▲ **A FILM STUDIO** in Germany contains one of two garden sets used by Stan Douglas in *Der Sandmann* (The sandman). In its final form, the artwork is projected in a gallery space. Like many of Douglas's installations, this one uses multiple perspectives, or camera angles, to shape what we are seeing. While a character reads and the camera pans the sets, we realize that one of the views we see is a memory and years have elapsed.

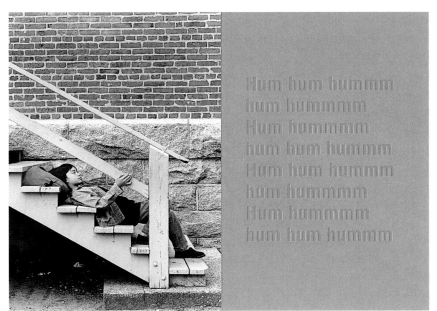

KEN LUM, *Hum, Hum, Hummm*, 1994

◀ **PICTURES AND WORDS** are often partners in the work of Ken Lum. Here, in a photo-painting from the 1990s, a boy reclines on some stairs beneath a brick wall. His dreamy look makes us think he is ducking school or waiting for friends. On the purple panel to the right, we read the bits and pieces of a hummed song. In comic-book tradition, they seem to be a caption for the picture. But the situation is ambiguous. The darkness of the shadow under the stairs, the grey light, and the boy's aloneness suggest a vulnerability. The dreamy look can be a disconnected one and the tone of voice in the hummed words can change into a challenge. In his various photo works and installations, Lum looks for the complexities that can underlie modest circumstances and modest heroes.

Glossary

Abstractionism, 26, 29, 35, 38, 41, 44–45, 48–49, 54, 60, 64
The pursuit of abstract art, which is an art with no recognizable subject. Concerned with colour, shape, and form, this style emerged in the early 20th century.

Acrylic, 49
A plastic-based paint that usually thins with water and dries much more quickly than oil paint. It is known for the brightness of its colour.

Automatistes, 44
A group of Montreal abstract artists led by Paul-Émile Borduas and influenced by the automatic drawing and writing techniques of the surrealists. Formed in the 1940s, they held exhibitions in Montreal, Paris, and New York.

Beaver Hall Hill Group, 43
A group of Montreal figure painters that included Edwin Holgate, Randolph Newton, Lilias Torrance Newton, and Prudence Heward. The name comes from the address of their studio building, which also serves as an exhibition space.

Conceptual art, 58–59
An art of ideas in which the artist's concept is regarded as more important than the final art object.

Contemporary Arts Society, 43
A group of painters, largely from Montreal, who pursued new directions apart from the Group of Seven. Formed by John Lyman, the group advocated a more international style of modern art through the 1930s and 40s.

Cubism, 45
An early movement in the history of modern art where subjects in painting and sculpture are broken down into various facets and planes, giving things the appearance of being made of "cubes."

Diploma picture, 24
A painting produced by artists submitted to mark the finish of their studies; the painting equivalent of a thesis paper.

Expressionism, 49
A modern art movement where the emphasis is on exaggerated shapes and colours that highlight emotional reactions to subject matter rather than form.

Folk art, 14
A tradition-oriented art usually made by untrained practitioners.

Genre painting, 20–21
The painting of scenes from daily life, often with emphasis on a moral story.

Graphic art, 32
An art of drawing and design associated with the requirements of printing.

Impressionism, 30–31, 38
An influential art movement that began in France in the 1860s and sought to capture fleeting perceptions of light and colour, often rendered in quick, broad brushstrokes.

Installation, 58, 61, 62, 64, 67
A contemporary style of sculpture that involves the planned organization of related objects or images in a gallery space.

Linear, 14
The quality of being like a line. A linear art is an art where outline predominates over colour and texture.

Modernism, 26, 38–39, 42–43, 45, 48
A style of art that predominated in the twentieth century. It's an art of contemporary concerns rather than traditional ones, usually inclined to abstraction.

Oil, 24, 41
A type of painting that relies on oil, usually linseed oil, to carry paint pigment. The paint can be applied thick or thin and, when dry, is long-lasting.

Painters Eleven, 49
The name of a group of abstract painters working in Toronto in the 1950s. It included Jack Bush, Oscar Cahén, Hortense Gordon, Thomas Hodgson, Alexandra Luke, Jock Macdonald, Ray Mead, Kazuo Nakamura, William Ronald, Harold Town, and Walter Yarwood.

Perceptual realism, 50–51
A term invented by London, Ontario, artist Jack Chambers to describe his paintings, which frequently began with photographic images that he would adapt to his own perceptual vision.

Performance art, 64
An art that incorporates the active participation of the artist in a theatre-like event.

Portrait, 5, 8, 10, 11, 14, 17, 18, 23, 34, 42–43
One of the standard genres of painting and photography devoted to rendering the likeness of a person.

Public art, 57
An art that is directed to large public audiences outside of the usual art gallery setting.

Refus global, 44, 45
The influential artistic manifesto of the Montreal Automatistes, calling for a new, radical sensibility in modern Quebec art that would leave tradition behind.

Regina Five (Five Painters from Regina), 49
The name of a group of Regina-based abstract painters in the 1960s. It included Kenneth Lochhead, Arthur McKay, Douglas Morton, Ted Godwin, and Ronald Bloore.

Royal Canadian Academy, 24, 25
An organization of professional painters in Canada founded in the nineteenth century to advance the practice and appreciation of art.

Sculpture, 6, 30, 53, 56, 57, 60, 61, 62, 63, 64, 65, 66
The art of three-dimensional form, traditionally involving carving, modelling, and casting.

Still life, 29
The painting of objects, often arranged on a table.

Surrealism, 65
A modern art movement that explored dreams, the unconscious, and the irrational.

Topographic drawing, 12–13
A type of drawing meant primarily to convey information on a place; a visual report.

Watercolour, 12, 13, 19, 24, 25, 38, 41
A kind of paint, favoured by 19th-century British artists, that dissolves in water. It is highly portable, so is often used on travels since it doesn't involve the more elaborate requirements of oil paint.

Jean Paul Riopelle, *Coups sur Coups* (detail), 1953

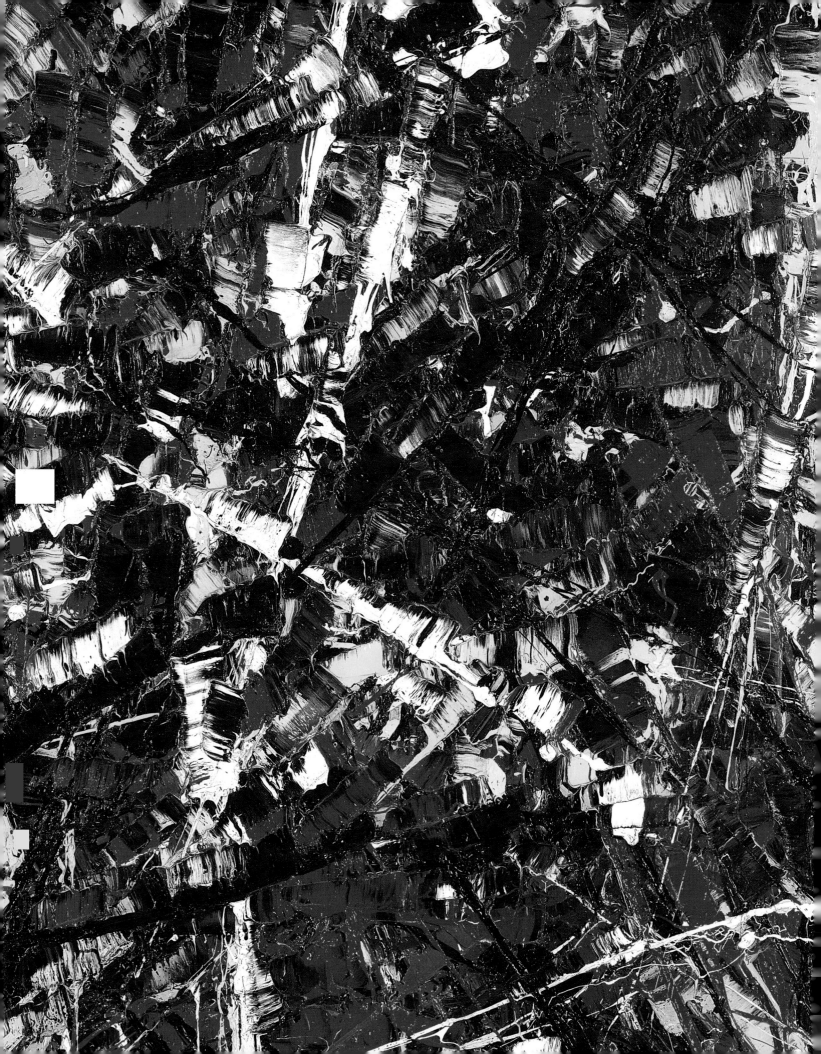

Picture Credits

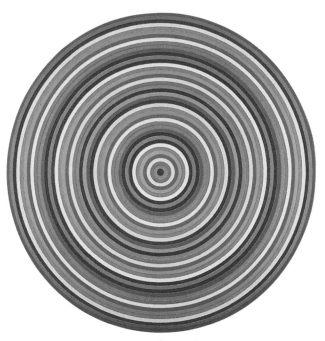

CLAUDE TOUSIGNANT, *Gong 88*, 1967

Key:
t: top; b: bottom; c: centre; l: left; r: right

Abbreviations:
AB: Art Bank; **AGH:** Art Gallery of Hamilton; **AGO:** Art Gallery of Ontario; **HHC:** University of Toronto Hart House Collection; **MACM:** Musée d'Art Contemporain de Montréal; **MBAM:** Musée des Beaux-Arts de Montréal; **MCAC:** McMichael Canadian Art Collection; **MMCH:** McCord Museum of Canadian History; **NAC:** National Archives of Canada; **NGC:** National Gallery of Canada; **PC:** Private Collection; **SMA:** Stark Museum of Art, Orange, Texas; **VAG:** Vancouver Art Gallery

Care has been taken to trace ownership of copyright materials contained in this book. Information enabling the publisher to rectify any reference or credit line in subsequent editions will be welcomed.

Cover: Front, top row (l to r): Borduas (*detail*): MBAM; Kane (*detail*): NGC; Snow (*detail*): Michael Snow; **middle row** (l to r): Carr (*detail*): VAG; Légaré (*detail*): AGO; Berczy (*detail*): NGC; **bottom row** (l to r): Kreighoff (*detail*): Power Corporation of Canada; Todd (*detail*): NGC; **Back, top row** (l to r): Cullen (*detail*): AGH; Anonymous (*detail*): PC; **middle row** (l to r): Sterbak (*detail*): NGC/Jana Sterbak; Colville (*detail*): AGH/Alex Colville; Suzor-Coté (*detail*): NGC; Todd (*detail*): NGC; **bottom row** (l to r): Pellan (*detail*): MACM/SODRAC; Notman (*detail*): MMCH; **Endpapers:** Bush: MACM/Estate of Jack Bush

Page 3: PC; **4, 72:** Eden Robbins Photography Inc.; **6:** tl, tr: Museum of Civilization, br: Glenbow Museum; **7:** Petroglyphs Provincial Park, Ontario Parks; **8:** tl: Seminaire de Québec; tr: Commemorative Chapel, Sainte-Anne de Beaupré; br: Hotel Dieu de Québec; **9:** c: Archives Départementales de la Gironde; **10:** t & b, **14:** tl, bl, tr, **17:** bl, **18:** br, **24:** b, **25:** t, b, **26**, **27:** t, **30:** t, **32:** t, **39:** t, **55:** NGC; **11:** tl, **22**, **23:** t, b: MMCH; **11:** tr: PC; **11:** bl, **17:** br: Musée du Quebec; **12:** t, b, **13:** b: NAC; **16:** t, b, **24:** t, **32:** b, **33:** t, bl, **34:** t, **35**, **37:** b, **38**, **39:** b, **45:** b, **46:** b, **49:** tr, **52**, **54:** t, **69:** AGO; **17:** t: AGO/PC; **18:** bl, **19:** br, bl: SMA; **19:** t: Royal Ontario Museum; **20:** Power Corporation of Canada; **27:** b, **44**, **60:** b: MBAM; **28**, **29:** t, b: NGC/SODRAC; **30:** b, **36:** b, **64:** bl: MCAC; **31:** t: AGH; b: Thomson Collection; **33:** br: University of Guelph Art Centre; **34:** b: Art Gallery of Greater Victoria/AGO; **36:** t: AGO/PC; **37:** t, **42:** b, **48:** b: HHC; **40, 41:** tr, l, **67:** b: VAG; br: British Columbia Provincial Archives; **42:** t: NGC/Private Collection; **43:** r: Art Gallery of Windsor; l: NGC/Private Collection; **45:** t: MACM/SODRAC; **46:** t: AGH/Alex Colville; **47:** t: Mira Godard Gallery/Christopher Pratt; b: AGO/AV Issacs Gallery; **48:** t: MACM/Estate of Jack Bush; **49:** bl, **70:** AGO/Claude Tousignant; br: AB/Kenneth Lochhead; **50:** t: Thomas Moore Photography/TD Bank Financial Group/Estate of Jack Chambers; **50:** b, **51:** b: London Regional Art Gallery/Estate of Jack Chambers; **51:** t: AB/Estate of Jack Chambers; **53:** t: AB/Murray Favro, bl: AB/Paterson Ewen; br: AGO/Ron Martin; **54:** b: Canadian Filmmaker Distribution Centre; **56:** tl: NGC/Michael Snow; b: AGO/Michael Snow; **56:** tr, **57:** Michael Snow; **58:** t: AGO/Iain Baxter; b: Vera Frenkel; **59:** t: AGO/Garry Neill Kennedy; b: Eric Cameron; **60:** t: AGO/Angela Grauerholz; **61:** tr: Barbara Steinman; br: AGO/Betty Goodwin; l: NGC/Jana Sterbak; **62:** tl, **63:** t: Susan Hobbs Gallery; r: A.A. Bronson; bl: Noel Harding; **63:** b: Tom Dean; **64:** t: University of British Columbia Museum of Anthropology; br: Patricia Deadman/NGC/Rebecca Belmore; **65:** t: Lawrence Paul Yuxweluptun; br: PC; bl: NGC/Carl Beam; **66:** l: Rodney Graham; r: Jeff Wall; **67:** r: David Zwirner Gallery

Index

OVERLEAF: *The palette of artist Douglas Walker (see page 4) in the veiwfinder of a digital camera*, 2001

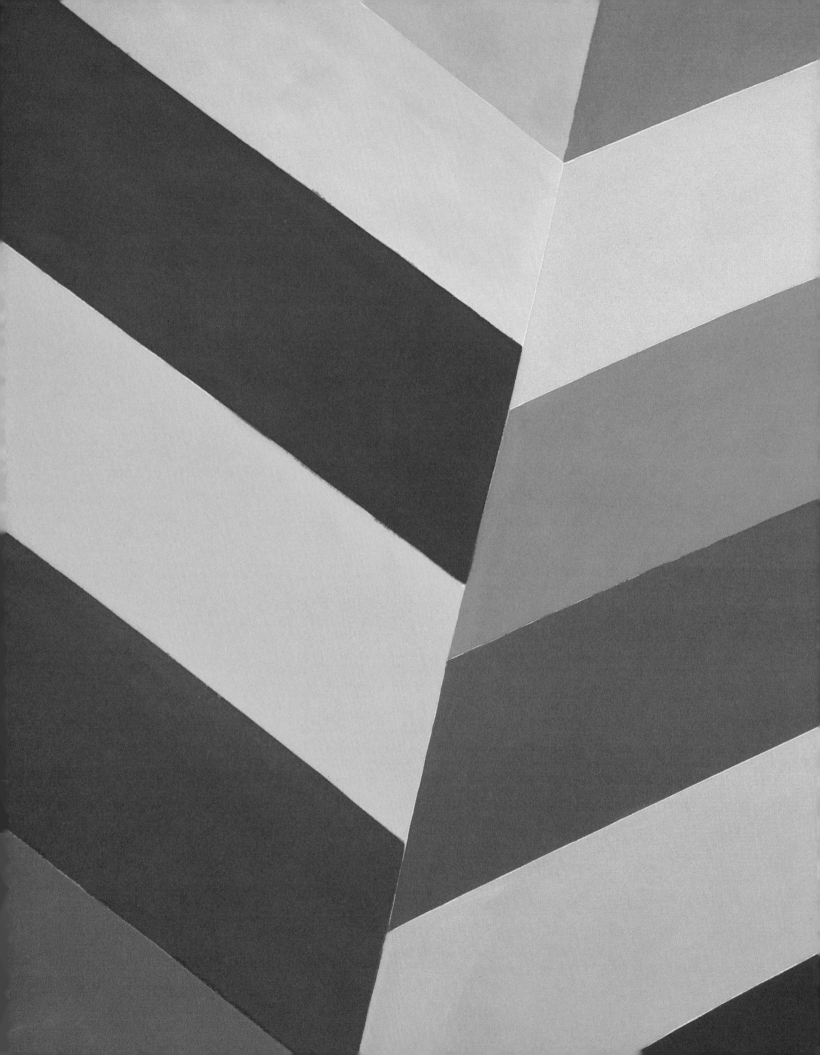